IMAGES
of America

ST. CLAIR SHORES

VILLAGE ON THE LAKE

THE *GRIFFON*. In 1678 French explorer Robert Cavelier de La Salle set up a shipyard near present-day Buffalo, New York. There, despite hostile Indians and mutinous workmen, his men built a ship during the winter and launched it early in the summer of 1679. They named the ship the *Griffon*. On August 7, 1679, aboard the *Griffon*, La Salle and his crew set sail across Lake Erie, and on August 11 they entered the Detroit River. The *Griffon* thus became the first sailing ship ever to traverse these waters. The next day they sailed into the lake, which they named Ste. Claire in honor of Sainte Claire of Assisi, whose feast day fell at that time. The *Griffon* sailed on to Green Bay, and after loading the ship with furs collected there for him, La Salle ordered the ship back to the Niagara region while he continued on to explore Lake Michigan. On September 18, the *Griffon* sailed out into Lake Michigan and was never heard from again. It was almost a hundred years before the next ship of any size was to sail across Lake St. Clair.

IMAGES
of America

ST. CLAIR SHORES

VILLAGE ON THE LAKE

St. Clair Shores Historical Commission

ARCADIA
PUBLISHING

ISBN 978-0-7385-0789-7

Published by Arcadia Publishing
Charleston SC, Chicago IL, Portsmouth NH, San Francisco CA

Printed in the United States of America

Library of Congress Catalog Card Number: 00107495

For all general information contact Arcadia Publishing at:
Telephone 843-853-2070
Fax 843-853-0044
E-mail sales@arcadiapublishing.com
For customer service and orders:
Toll-Free 1-888-313-2665

Visit us on the Internet at www.arcadiapublishing.com

CONTENTS

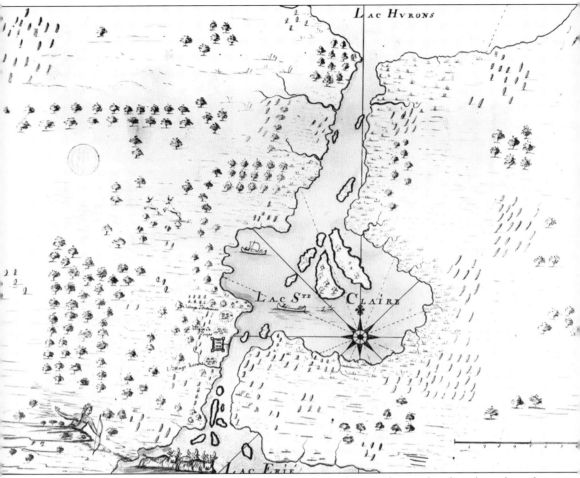

LAKE ST. CLAIR, 1702. This may be the first map of Lake St. Clair, and is thought to have been drawn by Antoine Laumet de Lamothe Cadillac the year after the founding of Detroit in 1701. Since the map lacks a title and date, historians have named it the "Buffalo Map" because of the image of an Indian shooting at a herd of buffalo at the edge of Lake Erie near the site of present-day Monroe, Michigan. (Courtesy of the Burton Historical Collection, Detroit Public Library.)

INTRODUCTION

During the year 2001 the city of St. Clair Shores hosted a series of events to commemorate the city's 50th anniversary. One of the most important of these events was the publication of this book.

Although the formal organization of our community as a city dates from 1951, the first settlement here dates from the late 18th century, when a small group of French "habitants" from the fort at Detroit settled north along the shore of Lake St. Clair, near the mouth of the Milk River. Originally known as L'Anse Creuse, this tiny settlement soon grew into a bustling farming community. The words L'Anse Creuse will be found on maps from the 18th century well into the 20th. Noted by the slight curve of the Lake St. Clair shoreline from Gaukler Point at the Milk River (the present site of the Edsel and Eleanor Ford Estate) north to the mouth of the Clinton River at present-day Mount Clemens, the term L'Anse Creuse has a variety of meanings: little crescent, small bay, shallow saucer, and little dipper. The phrase L'Anse Creuse was never anglicized, and though it has a variety of meanings, it has always retained its original French name.

As newcomers moved into this area known as L'Anse Creuse, they cleared the land, began farming, and the settlement grew northward along the shoreline. These early farms were located on the original French land claims and fronted the lake. They were long and narrow and extended back in some cases to present-day Harper Avenue. In fact, on early land abstracts, present-day Harper Avenue was originally called French Claim Road.

In 1837, the settlement of L'Anse Creuse became part of Orange Township. In 1843, the township name was changed to Erin due to the influx of settlers into this region from Ireland. Originally, the township covered an area that today includes the cities of St. Clair Shores, Roseville, Eastpointe, Fraser, and a small portion of Warren. In 1843, most of the population of the township (in 1850 this figure stood at 974) lived along the old River Road (later called Lake Shore Road), present-day Jefferson Avenue, and the Fort Gratiot Turnpike. The Turnpike, which was completed from Detroit to Mount Clemens in 1831, went through the township in a northeast direction and is today known as Gratiot Avenue.

By 1875 the township, while growing (the population had reached 2,500), was still largely a rural farming community with the farms producing a variety of crops. Along with their farms, the residents of the township also gave their names to many present-day roads in what would eventually become the city of St. Clair Shores. Nine Mile Road was first known as Defer Road after the Defer family. Ten Mile Road was called Labadie Road. The Labadies owned a large farm in that area. Eleven Mile Road was originally called Townhall Road, because the village townhall was located on it. Twelve Mile Road was called Champine, and Thirteen Mile Road was called Couchez after the families whose farms bordered those roads. One problem these farmers faced, however, was getting their cows (and farm produce) to market in Mount Clemens. It was a long way over to Gratiot from Jefferson. So, a shortcut was taken and the

local farmers called it Two Cow Path. Eventually this path became a well-traveled road and today we know it as Little Mack Avenue.

Erin Township continued to grow at such a rate that in 1911 the eastern half (present-day St. Clair Shores) was renamed Lake Township. By 1920 the population of Lake Township had reached almost 2,000. Over the next five years the township's population grew to 7,000 with 4,000 registered voters, 1,400 school-aged children, 350 telephones, and 2,100 electric customers. Thus, because of this growth, the township officially became the village of St. Clair Shores in 1925.

While the 1920s were a period of growth for the village, the 1930s and the Great Depression were a time of great hardship here. In fact, when the first permanent village office was built at the northwest corner of Jefferson Avenue and Eleven Mile Road in 1934, it was constructed almost entirely of donated materials and donated labor.

The next period of growth for the village of St. Clair Shores came after World War II, as part of the great population boom of southeastern Michigan. In 1940, the population of the village stood at 10,405, by 1950 it had nearly doubled to 19,823, and as a result St. Clair Shores was known as "the largest village in the world". It was also at this time that the residents of the village finally, after nine years and six elections, voted on January 9, 1951, to adopt a new charter establishing St. Clair Shores as a city with a council-manager form of government. Following this election, the first city council took office on January 15, 1951.

While the growth of the village during the 1940s was indeed impressive, it was nothing compared to the explosion of the 1950s. From 19,823 residents in 1950 the new city's population leaped to 76,657 by 1960. It was a time of unparalleled growth for the city—hundreds of new subdivisions, thousands of new homes, and miles of new water mains, sewer lines, and paved streets.

This growth continued into the next decade as well with the city's population reaching 88,093 by 1970 and by the mid-1970s it was estimated to be at well over 93,000. Then, by 1980, even though the number of housing units continued to grow, the population of St. Clair Shores, for the first time in its history, began to decline. Due to an aging population and a decrease in family size, situations that were occurring in all of Detroit's older suburbs, the city's population fell to 76,210 in 1980, 68,107 in 1990, and to 63,096 in the year 2000.

Through the use of maps, drawings, and photographs selected from the extensive archives of the St. Clair Shores Historical Commission, the story of the growth and development of our little village and booming city is told. Here readers will find views of Lake St. Clair, the Milk River, and the many 19th century families and farms that saw the growth of the township. Here also are the stories of the infamous Blossom Heath Inn, Jefferson Beach Amusement Park, the grand Masonic Country Club, and the Interurban Railway. In addition, readers will find the story of our schools, our churches, our businesses, and the places where we play.

Through the pages of this book, the Historical Commission hopes that readers will come to gain a better understanding of our city and in this fashion help us preserve the heritage of our fine community. We also hope that you enjoy reading this story of St. Clair Shores—this village on the lake.

One

EARLY YEARS
1875–1910

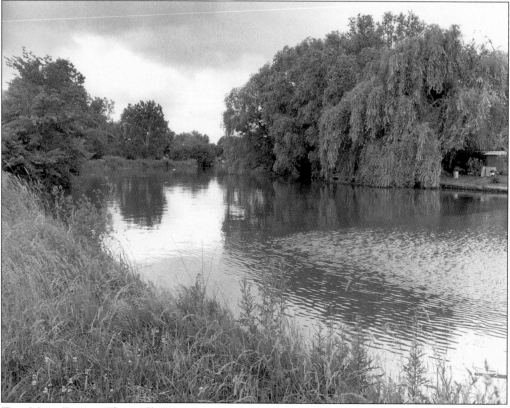

THE MILK RIVER. The Milk River is one of our community's most distinctive features. It has been shown on maps of the area as early as 1793. The river once drained a swampy area so thick with vegetation that it was called the Black Marsh. Although the Black Marsh has long since been filled-in and the area subdivided, a small part of the Milk River still makes its way in a slow, winding fashion into Lake St. Clair through the southern part of St. Clair Shores. The river has always been muddy and slow. It is at times whitish-brown in color, so thick that you cannot see the bottom, even if it is only four feet down. To the early French settlers it was as thick as milk—so they named it the Milk River. This present-day view of the Milk River was taken from the bridge on Jefferson Avenue looking west.

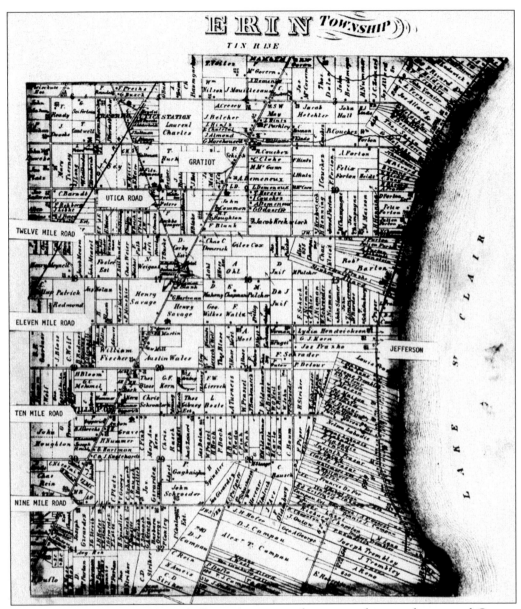

ERIN TOWNSHIP, 1875. Macomb County's most southeast township was first named Orange when it was formed on March 11, 1837, the year Michigan was granted statehood. Six years later, on March 9, 1843, the township name was changed to Erin due to the large influx of settlers into this region from Ireland. Originally the township covered an area that today includes the cities of St. Clair Shores, Roseville, Eastpointe, Fraser, and a small portion of Warren. In 1843, most of the population of the township lived along Lake Shore Road (also called the old River Road), present-day Jefferson Avenue, and the Fort Gratiot Turnpike. The turnpike, which was completed from Detroit to Mount Clemens in 1831, went through the township in a northeast direction and is today known as Gratiot Avenue. In 1875, when this map was published, the township was still a rural farming community. The long narrow strips of land that extend westward from the lake are the original French claims that were granted to the first settlers of the area. This eastern portion of the township is today the city of St. Clair Shores.

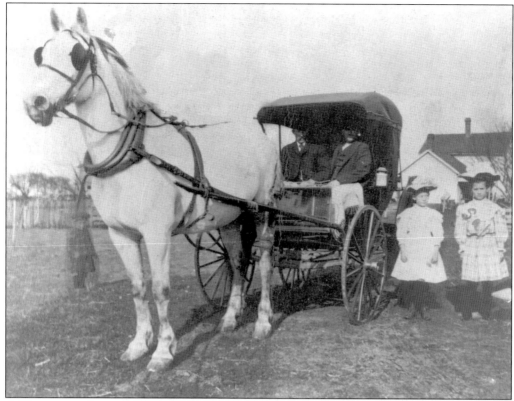

A HORSE AND BUGGY. Here, a local St. Clair Shores family dressed in their Sunday best pose for the camera with their horse and buggy. Although a typical family of the period, we do not know their names. "Dad" is holding the reins and "Sal" is the little girl on the right. The horse's name is "Dolly."

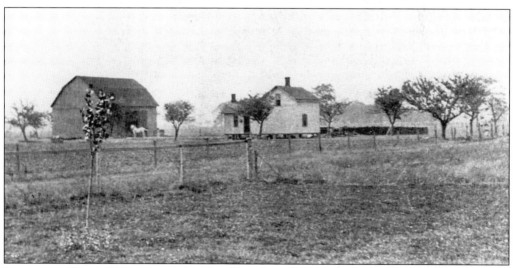

TROMBLEY FARM. This view of the Trombley Farm dates from the late 1800s. The farm was located at Jefferson Avenue near Labadie Road (present-day Ten Mile Road). Those are fruit trees along the fence in the foreground.

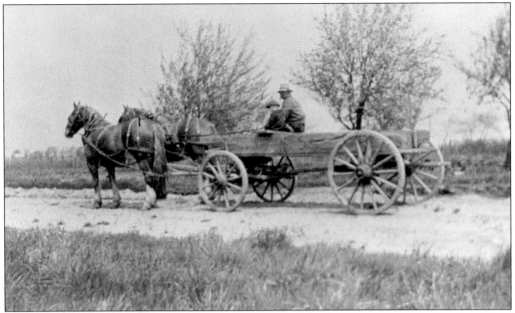

COUCHEZ FARM. This is how the local farmers of the day got their produce to market. Here Edmund Couchez (the boy to his left is not identified) is seen with his Clydesdales and wagon. During the late 1800s and early 1900s there were several branches of the Couchez family living in St. Clair Shores. This Couchez farm was on Jefferson Avenue near present-day Maple Street.

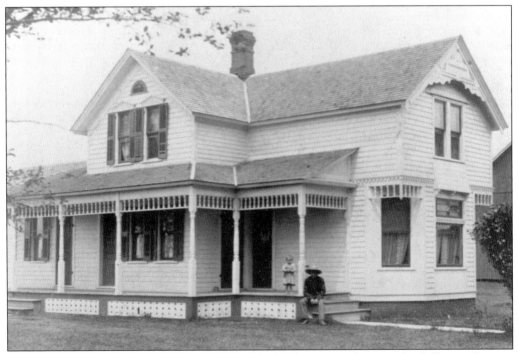

FRAZHO FARMHOUSE. Here is the Frazho family farmhouse at what is today Jefferson Avenue and Centennial Street. Little Arthur Frazho is standing on the porch and Clifford Frazho is sitting on the step.

COUCHEZ FARMHOUSE. This Couchez family farm and farmhouse were located at the northwest corner of present-day Thirteen Mile Road and Harper Avenue. Today this is the site of a shopping center. For many years Thirteen Mile was known as Couchez Road.

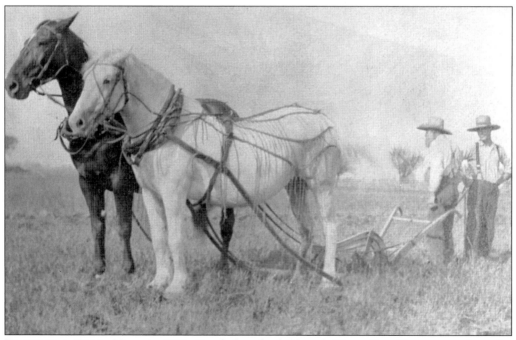

PLOWING A FIELD. Here, in 1911, Frank (on the left) and Albert Trombley stop and rest for a moment while plowing. The Trombley farm was located on Jefferson Avenue near Labadie Road (present-day Ten Mile Road).

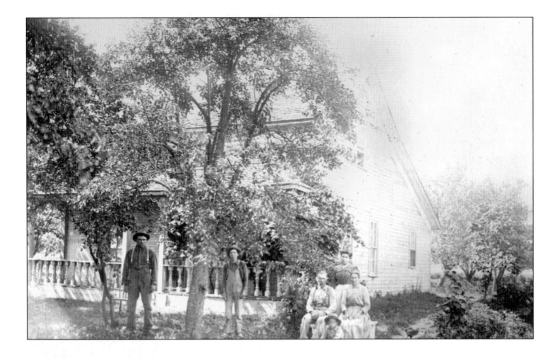

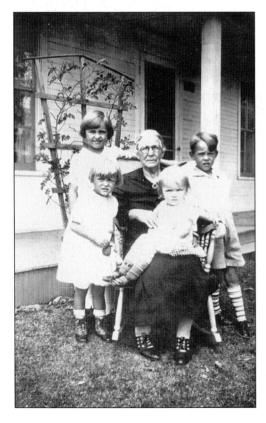

THE JOHN AND ERNESTINE GREEN FAMILY.
In 1868, Prussian immigrants John and Mary Selinsky bought farmland in Erin Township. They built this salt-box style house using solid log construction covered with clapboard. The house was located on present-day Eleven Mile Road near Grant Street. The Selinskys gave the house to their daughter Ernestine when she married John Green in 1874. Above, the Greens are joined by four of their six children in July 1899. John and Ernestine are seated with Walter in front of them and Mary in back. William (left) and Charles are standing. Below, Ernestine poses with four of her grandchildren, c. 1930. Mardell Green is sitting on Ernestine's lap with (left to right) Eleanor, Florence, and Edsel Prest. In 1975, the Selinsky-Green Farmhouse was moved to Jefferson Avenue and Eleven Mile Road and restored as the city's historical museum.

THE JOHN AND IDA GREEN JR. FAMILY.
In 1907 John Green Jr. married Ida Belle Smith. Standing behind John (in their wedding picture) is his sister Mary. The name of the man behind Ida is not known. At the time of his marriage, John was working as a lineman for the Detroit United Railway (DUR), more commonly known as the Interurban. Soon after their marriage John and Ida bought this saloon and grocery store on Jefferson Avenue at present-day L'Anse Street. John ran the saloon and Ida took care of the store. Below, in 1910, the Greens and two of their children stand on the porch of their saloon and store. John is holding Evelyn; Roy is standing with his mother. The man on the left is not identified. At first the farmers of the area prospered, but during Prohibition the Greens were forced to sell the business because the grocery store did not provide enough income to support their family. After Prohibition the grocery store closed and the saloon prospered. Today it is the very popular Blue Goose Inn.

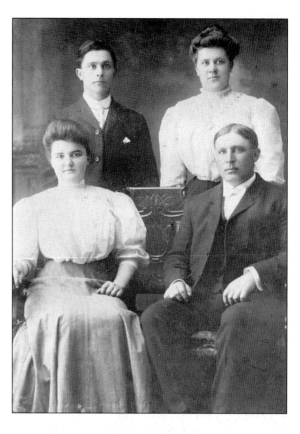

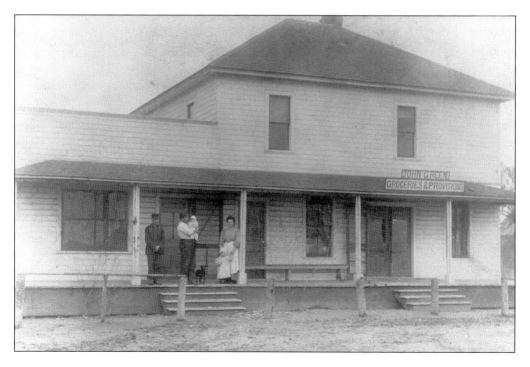

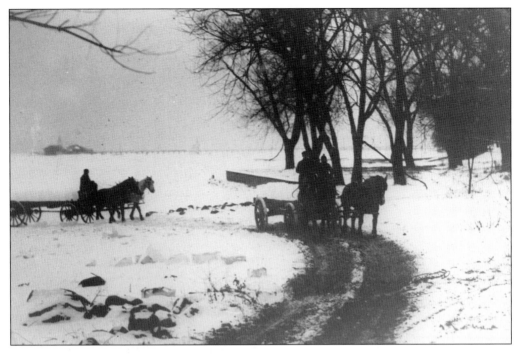

ICE CUTTING ON LAKE ST. CLAIR, 1912. Before the days of home refrigerators, St. Clair Shores residents used ice and ice boxes to preserve their food. Lake St. Clair was where they got their supply of ice. Here, (above) August Blumline Sr. (in the first wagon) and Aloysius Robertjohn haul ice from the lake. Below, an ice cutting crew slides blocks of ice from the lake onto a sled which will then be hauled ashore and the ice stored in local ice houses.

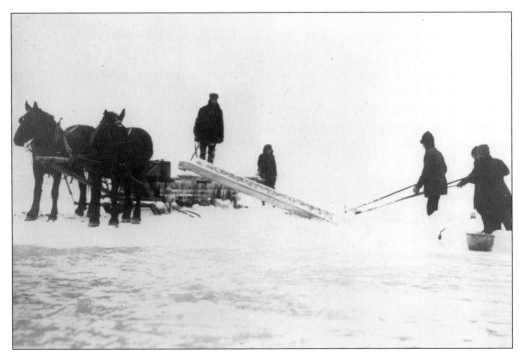

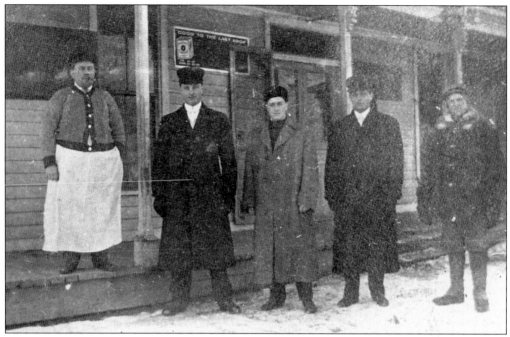

LAKESHORE HOUSE TAVERN, 1908. Along with the Blue Goose Inn, the Lakeshore House Tavern on Jefferson Avenue near present-day Millenbach Street was (and still is to this day) one of the area's most popular roadhouses. Here, standing on the porch of the Lakeshore House Tavern are, from left to right, Ed Heintz, John Maison, Henry Frazho, Jesse Maison, and Frank Malso.

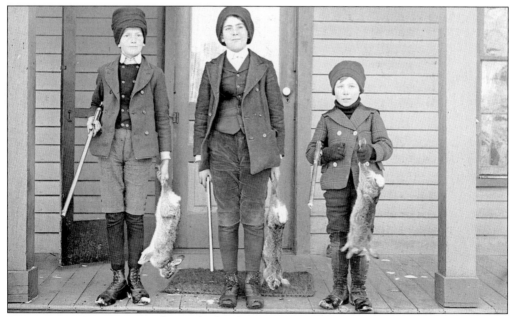

THE FISTLER BOYS, 1903. The Fistler brothers, Walter, Jack, and Dwight, are on the porch of their house after a successful afternoon of rabbit hunting. Note the snow on their boots, winter jackets, and knickers. In this very rural farming community, rabbit hunting for food and sport by young boys was very common at the turn of the last century.

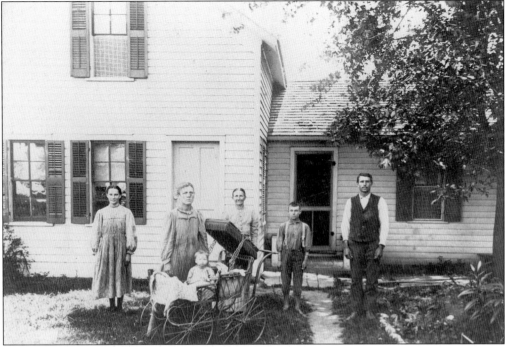

THE TROMBLEY FAMILY, 1898. Here, the Trombley family poses before their farmhouse on Jefferson Avenue at present-day Glenbrook Street in 1898. They are, from left to right, Nettie, Pauline, Albert, and William Trombley. Standing in front is Mrs. (?) Prell with the very handsome baby carriage.

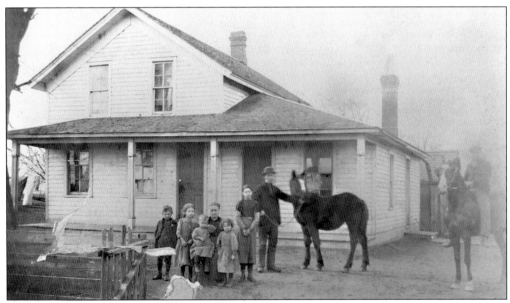

THE MAISON FAMILY, C. 1900. The Maison family stand before their farmhouse, located at present-day Francis Street near Greater Mack Avenue. The children, from the left, are Benjamin, Rose, Archie and Tillie. Mother Rose Maison is holding Archie on her lap. The girl at right and men with horses are not identified.

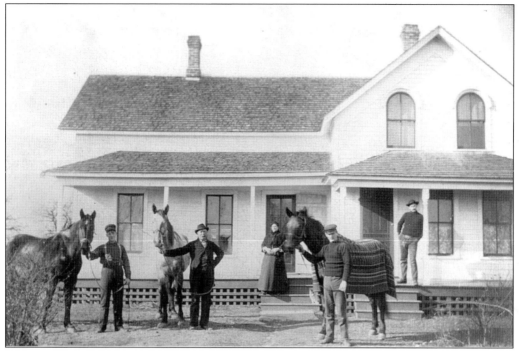

THE MELOCHE FAMILY, 1905. The Meloche family (and their horses) gather before their farmhouse on Jefferson Avenue near present-day Avon Street. They are, from left to right, Arthur, Noah, Mary Katherine (on the steps), Frank, and Fred. We do not know the names of the horses.

THE MAISON FAMILY, 1894. At the turn of the last century, the Maison family (like several other families in the community) was very large. There were several branches of the family and each had its own farm. This group of Maisons stand before their farmhouse on Twelve Mile Road. Note the elaborate beards and mustaches on several of the male members of the family.

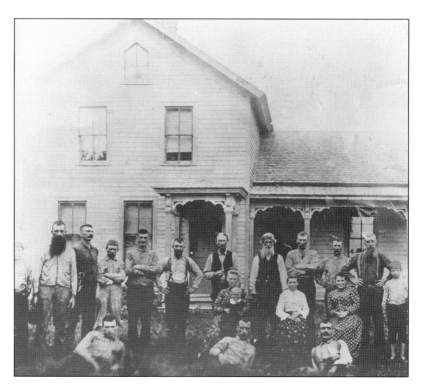

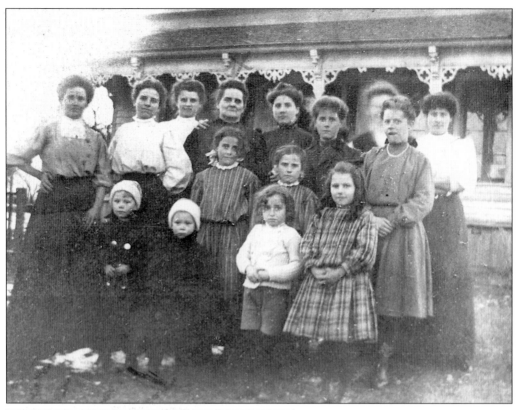

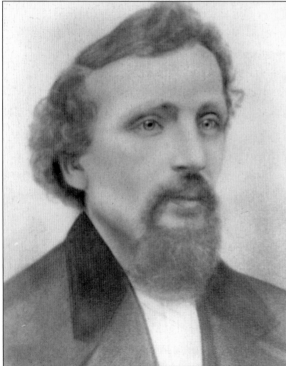

THE CHAMPINE FAMILY, 1900. The ladies of the Champine family gather for this group picture before the family farmhouse sometime around the turn of the last century. The Champine farm was on present-day Twelve Mile Road and for many years the road was known as Champine Road.

FRANK JORAH. A blacksmith by trade, Frank Jorah was born in Switzerland on May 16, 1845. After settling in the village of L'Anse Creuse he married Catherine Defer and they raised a family of seven children. Jorah died here on March 23, 1902.

CATHERINE DEFER JORAH. A lifetime resident of old L'Anse Creuse, Catherine was the daughter of Antoine Defer and Mary Ann Corbett. The Defer farm was near present-day Jefferson Avenue and Nine Mile Road, and for many years Nine Mile was known as Defer Road. Catherine married Frank Jorah and they had seven children: Frank, Jennie, Sylvester, Clarence, Eugene, Margaret, and Mattie.

THE LABADIE FAMILY, 1910. Nelson and Teresa Labadie (front center) gather with their family to celebrate their 50th wedding anniversary. In the back row, center, is Father O'Shea, the long-time (1900–1929) pastor of St. Gertrude's Roman Catholic Church. The Labadie farmhouse was on the southwest corner of Jefferson Avenue and present-day Ten Mile Road. For many years Ten Mile Road was known as Labadie Road.

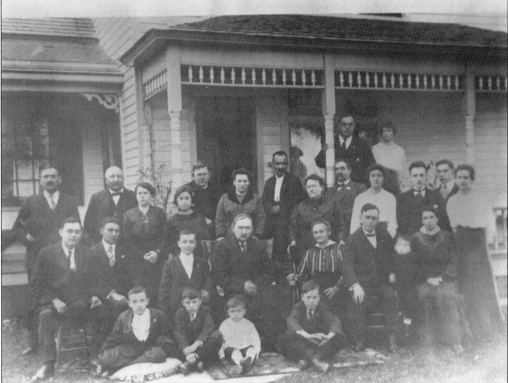

WILLIAM MELDRUM. Along with the Couchezs, Champines, Defers, Frazhos, Labadies, Maisons, and Verniers, the Meldrum family were long time residents of the township and their descendants are still found living in the city today. William Meldrum's farm was on Jefferson Avenue north of present-day Masonic Boulevard.

BRUNO COUCHEZ (1834–1927). Bruno Couchez and his family lived on their farm at the north end of the township. His brothers Englebert and Benjamin also owned farms nearby. These farms remained in the family for years and the Couchezs were still plowing this land with horses well into the 1940s.

CATHERINE COUCHEZ. Catherine Paclet Couchez was the wife of Bruno Couchez. Here she is seen at her house on present-day Thirteen Mile Road. In fact, during the early years of the township and village, Thirteen Mile Road was known as Couchez Road.

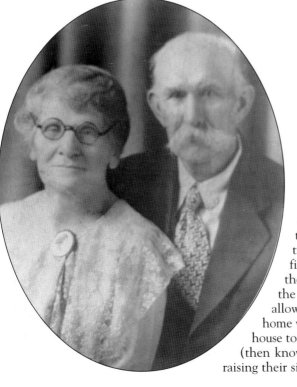

ADOLPH AND CATHERINE BLUMLINE. The Blumline family eked out a living on their small farm along the banks of the Milk River by growing vegetables, trapping muskrats, duck hunting, and fishing. In 1914 Henry Ford bought their farm (which later became part of the Edsel and Eleanor Ford Estate) and allowed Adolph and Catherine to take their home with them. The Blumlines moved their house to Jefferson Avenue and Nine Mile Road (then known as Defer Road) and there finished raising their six children.

23

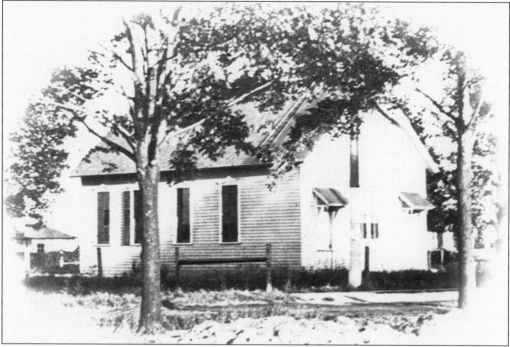

LAKE SHORE SCHOOL, 1898. The Lake Shore School District is the oldest of the three public school districts in St. Clair Shores. It is believed that the first public school in the township was established in 1838. This image was taken around 1898.

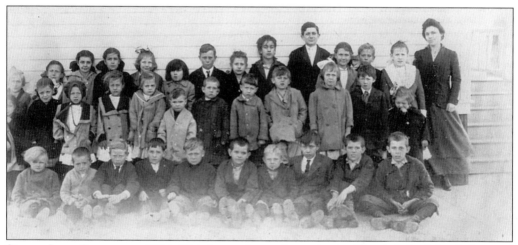

SOUTH LAKE STUDENTS, 1914. This image shows the students of South Lake School. Pictured here are, from left to right: (front row) Allen Pollock, Otto Weber, Claude Lanstra, Harvey Kuss, Clarence Whitmore, Walter Hilgendorf, Alvin Whitmore, Adolph Defer, John Hilgendorf, and Arthur Hilgendorf; (middle row) Rosemary Tucker, Florence Tucker, Rosemary Defer, Florence Defer, Clara Defer, Aloysius Robertjohn, Robert Frasard, Elmer Defer, Earl Powers, Norah Englehardt, Arthur Ullrich, and Beatrice Jorah; (back row) Mary Pollock, Mildred Newberry, Violet Robertjohn, Elizabeth Kuss, unidentified, unidentified, Harold Lanstra, Beatrice Defer, unidentified, Stanley Newberry, Beatrice Newberry, Edgar Lanstra, Elsie Ullrich, and Mrs. La Forbe, teacher.

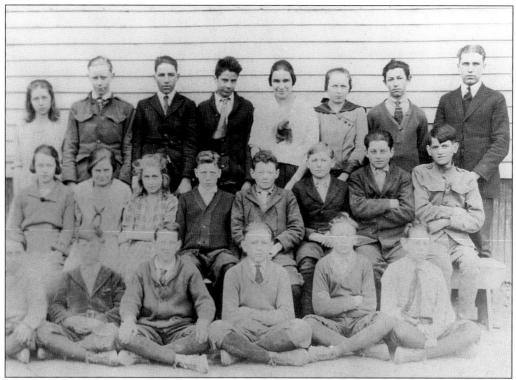

LAKE TOWNSHIP DISTRICT NO. 3 CLASS, C. 1922. The school was originally Erin Township District No. 8, formed in 1898. Lake Township was carved out of Erin Township in 1911 and L'Anse Creuse at that time. No. 3 was in the north end of St. Clair Shores, the present-day Lake Shore School District. The children are not identified.

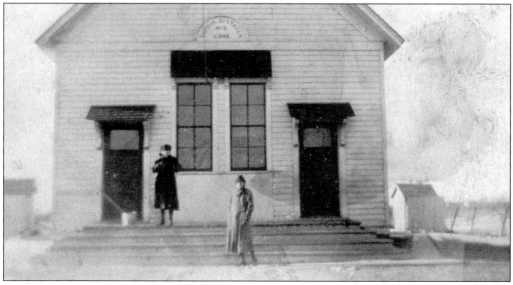

LAKE TOWNSHIP DISTRICT NO. 2 SCHOOL, 1910. Two women pose on the steps of Lake Township District No. 2 School in this undated photograph. Note the outhouses on both sides of the school. This is the old Erin Township District No. 5 School, which changed titles around 1910.

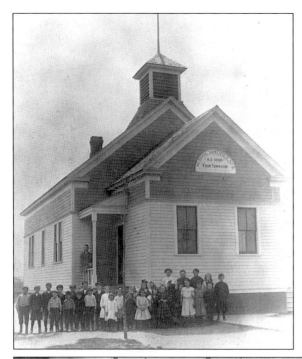

ERIN TOWNSHIP DISTRICT No. 8 SCHOOL. Located on Defer Road (now Nine Mile Road) west of Greater Mack, this school was formed July 25, 1898 by a 17–16 vote taken to divide the district. Twenty-four students were needed to start a school district, and 26 were found. Erin No. 5 schoolhouse and land was sold and the money, $169, was split between the No. 5 and No. 8 districts. This may be a photograph of the original class in the new school.

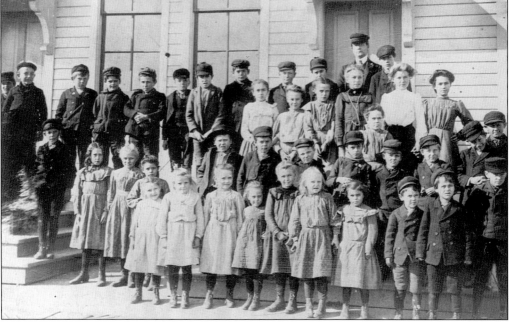

ERIN TOWNSHIP DISTRICT No. 5 SCHOOL, 1905. Located at Jefferson Avenue near Lakeland Street in 1905, Erin Township District No. 5 School had been moved from its old site at Labadie Road and Jefferson Avenue to land purchased from Ben Couchez in 1898. Legend has it that when the school board was driving in a buggy on Jefferson Avenue looking for the site of the new school, they spotted Miss Nieman, the teacher, sitting at a desk in a field. The school was rebuilt around her, on that spot. Before the split in 1898, there were 94 students in the district. In this photograph, teacher Mr. Charles Whitney stood in the doorway behind his class.

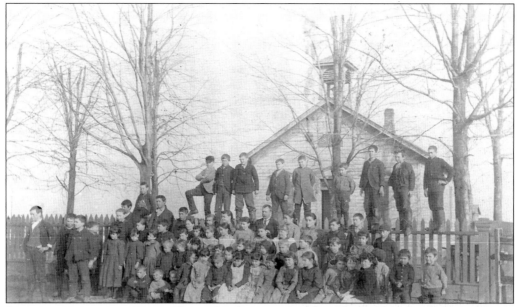

SCHOOLHOUSE BY THE LAKE. This undated image of a school by the lake has been tentatively identified as the log schoolhouse for District No. 5 that stood at Labadie Road (Ten Mile Road) and Jefferson Avenue on the Labadie farm. It was built around 1870 and opened with 65 students.

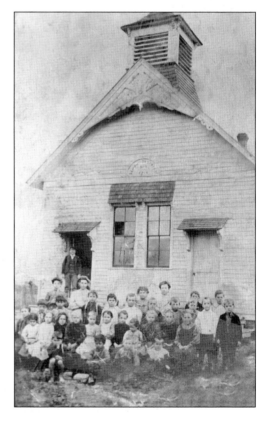

ERIN TOWNSHIP DISTRICT No. 5 SCHOOL, 1898. This is an 1898 image of Erin Township District No. 5 School around 1898, with its gingerbread trim, bell cupola, and district sign—around the time of the division of Districts No. 5 and No. 8.

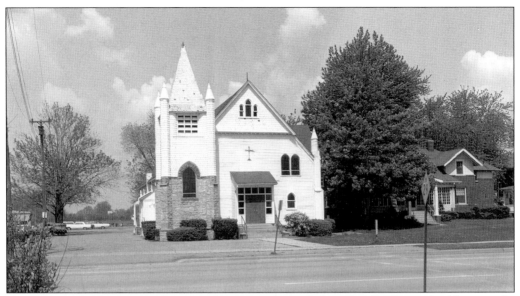

ST. GERTRUDE CATHOLIC CHURCH. St. Gertrude Catholic Church, the city's oldest parish, dates from 1826 when it was founded as a mission chapel. Originally named St. Felicity, the chapel was built on the shore of Lake St. Clair near the foot of present-day Shook Road. Because of rising lake levels the old chapel was abandoned in 1855. In 1858 the mission was rebuilt on Jefferson Avenue (at present-day L'Anse Street) on land bought from the Vernier family and was renamed St. Gertrude. The church in this view was built in 1897.

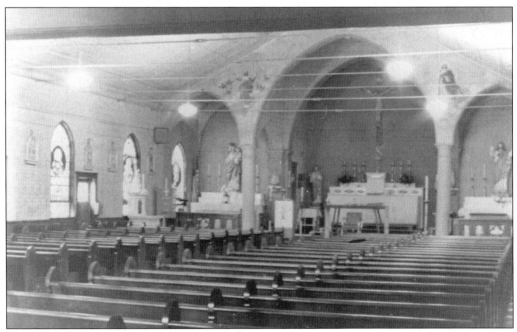

INTERIOR OF ST. GERTRUDE CATHOLIC CHURCH. This is an interior view of the 1897 church facing the altar. Note the iron rods (along the top of the picture) that held up the walls. This church was razed in 1965 after which the present church was built. In 2001 the congregation of St. Gertrude celebrated their 175th anniversary.

Two

TOWNSHIP YEARS
1911–1924

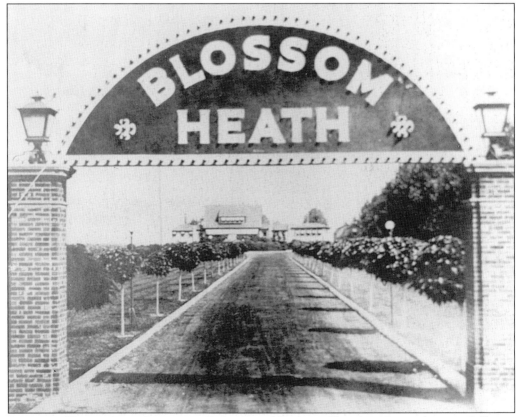

BLOSSOM HEATH INN. Stepping off the Rapid Railway Shoreline Interurban on Jefferson Avenue, this pleasant driveway to Blossom Heath greeted the visitor. This postcard view from the 1920s showed the catalpa trees lining the path to the front door and the beautiful grounds surrounding the property.

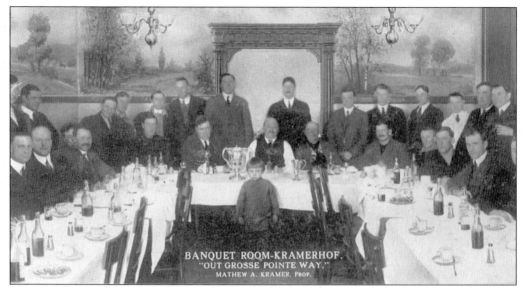

THE BANQUET ROOM OF THE KRAMERHOF. Mathew A. Kramer built the Kramerhof roadhouse in 1911. The inn was licensed to sell distilled or brewed malt liquors. The original square banquet room was painted with murals and had carved wood trim on walls and doors. Mr. Kramer was an avid ice boater and yachtsman. The trophies on the table suggest an awards banquet. Mathew Kramer died in March 1917 at the beginning of Prohibition.

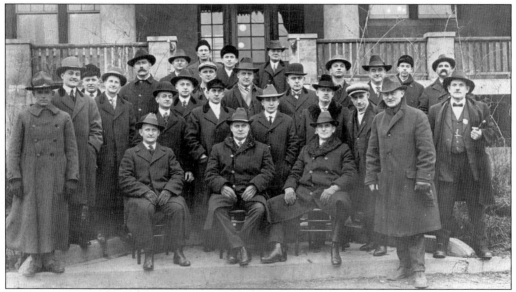

PARTY AT THE KRAMERHOF, C. 1915–1918. The Detroit Urban Railway (D.U.R) sponsored parties at the Kramerhof such as this one, formally recorded at the entrance to the roadhouse. The partygoers, from left to right, are as follows: (front row) Sheriff William Caldwell, Sheriff William Hartway, George Eckstein (businessman), and Mr. Hatcher; (middle row) Harry Broderick, unidentified, unidentified, unidentified, and Mr. McMannus (wearing derby); (back row) Don Wessondorf, Police Chief Art Russo, Art Ullrich, Sheriff John Spaller, Harvey Miller, unidentified, unidentified, Pete Moran, John Maison (Superintendent of Lake Township), Sheriff George Smith, unidentified, and Sam Lowenstein.

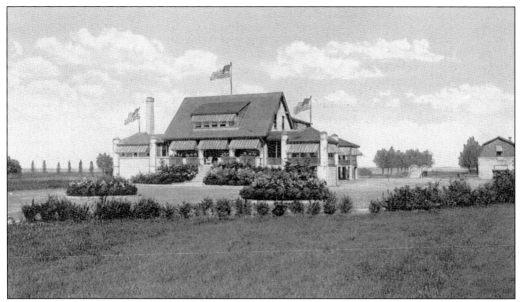

BLOSSOM HEATH INN, EXTERIOR VIEW. This 1929 postcard view of Blossom Heath "on the Lakeshore Drive" was an enticing ad for visitors from the Detroit area to try "a suburban restaurant of exceptional merit" which was "open all year". Proprietor William McIntosh was born in Canada in 1873 and had come to Detroit in 1899. He ran a saloon in Detroit before Prohibition and also managed prizefighters. He purchased Blossom Heath in 1920 with partner Harry C. Frazer.

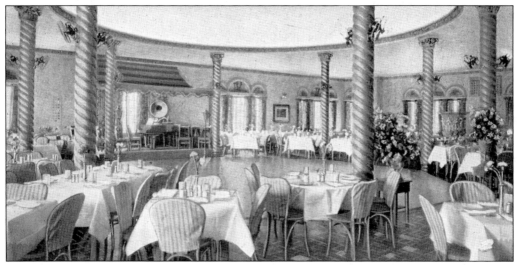

THE BALLROOM AT BLOSSOM HEATH. The ballroom in this 1929 postcard view centered on the wood dance floor with its echoing acoustics and twisted pillars along the edge. William McIntosh built the two wings including the ballroom, which was called the Pavilion Royale in the 1920s. Dress was formal and "they charged a dollar just to sit at a table without eating anything" according to a local resident. The beautifully restored ballroom is still used today.

DINNERS....
that made BLOSSOM HEATH famous
Served from 6 p. m. till 11 p. m.

———— ❧ ————

Hearts of Celery	Assorted Relishes	Mixed Olives

Fresh Crab Meat Cocktail	Fresh Fruit Cocktail	Fresh Shrimp Cocktail
Antipasto	Marinated Herring	Tomato Juice Frappe

Potage du jour	Consomme	Essence of Tomato

No. 1—Frog and Broiled Whitefish	$2.00
No. 2—Frog and Broiled Sturgeon Steak	2.25
No. 3—Frog and Baby Lobster	2.00
No. 4—Frog and Frog	2.00
No. 5—Frog and Chicken	2.00
No. 6—Grilled Double French Lamb Chops and Bacon	2.00
No. 7—Frog and Grilled Double French Lamb Chops and Bacon	2.25
No. 8—Filet Mignon with Fresh Mushrooms	2.00
No. 9—Frog and Filet Mignon with Fresh Mushrooms	2.25
No. 10—Sirloin Steak (One Pound solid Meat)	2.50
No. 11—Frog and Sirloin Steak (One Pound solid Meat)	2.75

Fresh Vegetable	Potatoes du jour

Salad in Season

Ice Cream, any flavor		Lemon or Orange Sherbet
Parfait Blossom Heath	Home Made Pie	Petit Fours

- or -

Imported Roquefort, Swiss, Camembert Cheese

Coffee	Tea	Milk	Iced Tea	Iced Coffee

PRICE OF THE ENTREE IS THE PRICE OF COMPLETE DINNER

BLOSSOM HEATH MENU. During the 1920s the Blossom Heath Menu had frog on many entrees,

SUGGESTIONS AFTER 11 P. M.

FROM THE CHARCOAL BROILER

Sirloin Steak garni (for one)	$2.00
Sirloin Steak garni (for two)	4.00
Sirloin Steak Minute garni	1.50
Filet Mignon garni	1.50
French Lamb Chops (2)	1.00
Milk-Fed Chicken	1.25

Broiled Lobster	According to size	Spaghetti any Style	1.00
Lobster Newburg	$1.75	Ham or Bacon and Eggs, Country Style	.90
Crabmeat Newburg	1.75	Welsh Rarebit	.75
Frog Legs Blossom Heath	1.50	Golden Buck	.80
Chicken a la King	1.50	Scotch Woodcock	.75
Chicken Poulette	1.25		

SANDWICHES

No. 1—Blossom Heath Special (Swiss Cheese, Ham, Turkey, Cole Slaw, Russian Dressing, Rye Bread)	$1.25
No. 2—Sandwich Basino (Bacon, Chicken, Tomato, Lettuce, Mayonnaise, Toasted Cheese)	1.25
No. 3—My Own (Scrambled Eggs with Chopped Onions, Ham, Green Peppers, Toasted)	1.00
No. 4—Fried Chicken Sandwich, Garnish	1.25
No. 5—Sirloin Steak Sandwich, Garnish	1.50
No. 6—Club Sandwich	.90
No. 7—Caviar Sandwich	.90
No. 8—Chicken Sandwich	.60
No. 9—Ham or Tongue Sandwich	.50
No. 10—Roast Beef Sandwich	1.00
No. 11—Lettuce and Tomato Sandwich	.35
No. 12—Imported Swiss Cheese Sandwich	.50

SALADS

Fresh Lobster	$1.50	Fresh Fruit	.80	Sliced Tomatoes	.30
Fresh Crabmeat	1.75	Pineapple, Cream Cheese, Lettuce, French Dressing	.50	Potato	.30
Fresh Shrimp	.90			Russian Dressing	.50
Chicken	1.25	Chef Special	.90	Thousand Island	.40
Roast Beef	1.50	All Green Salads with French Dressing	.40	Roquefort	.45
Blossom Special	1.50			Mayonnaise	.30

DESSERTS and ICE CREAM

Crepes Suzette	$1.25	Petit Fours	.50	Any Flavor Ice Cream	.35
Peach Flambe	1.25	Baked Alaska	.75	Lemon or Orange Sherbet	.30
French Pancakes	1.00			Parfait	.35
French Pastry	.25	Pound Cake	.30	Peach or Pear Melba	.50

All Imported Cheese .40, with Bar-le-Duc .60

Coffee with Cream .20	Demi Tasse .15	Milk .20	Tea .25

one of the popular local roadhouse food choices, as well as rabbit and wild game.

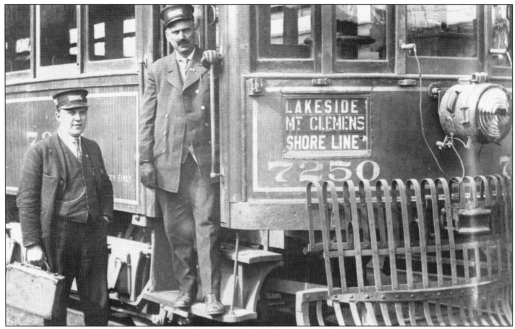

RAPID RAILWAY SHORELINE INTERURBAN. Oscar Smith and Nelson Labadie, from left to right, are seen boarding car #7250 to Mount Clemens. The Shoreline route followed Jefferson Avenue through St. Clair Shores and turned up Crocker Boulevard to Mount Clemens. The term "Lakeside" came from the Mount Clemens and Lakeside Traction Company which owned the tracks in that city. The Rapid Railway operated from 1898 to 1923.

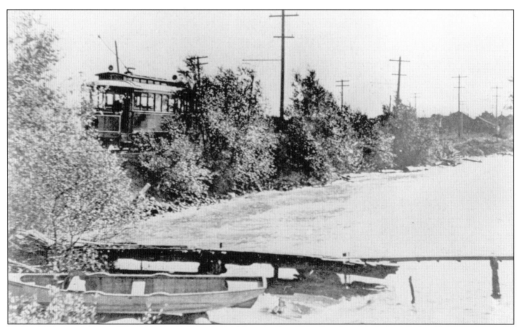

THE SHORELINE DIVISION INTERURBAN ALONG LAKE ST. CLAIR. This undated image illustrates the closeness of the Shoreline tracks to Lake St. Clair. Summer stops included Gaukler's Point, Willow Beach, Labadie's store, Defer Road, Jefferson Beach, and Bay View.

GAUKLER'S POINT INTERURBAN STOP. Photographed in August 1917, Gaukler's Pointe, named for one of the previous landowners, is close to the entrance of the Milk River where it flows into Lake St. Clair. It is now part of the Edsel and Eleanor Ford Estate in Lake Township. Mr. Ford moved the road and the Interurban track when he purchased the land for his estate. The closeness of the road to the track is very clear in this scene.

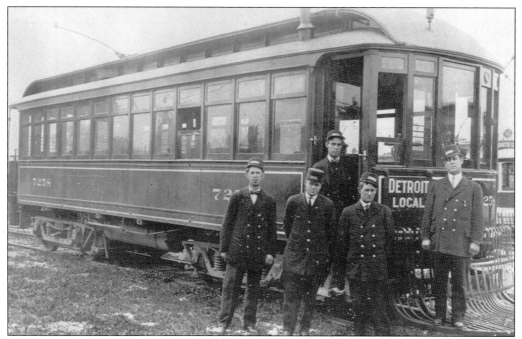

INTERURBAN CAR #7258—SHORE LINE DIVISION. The 40-foot-long, 42,000-pound car went into service on the Shoreline Division in 1896. Two Westinghouse No. 76 motors propelled the car.

35

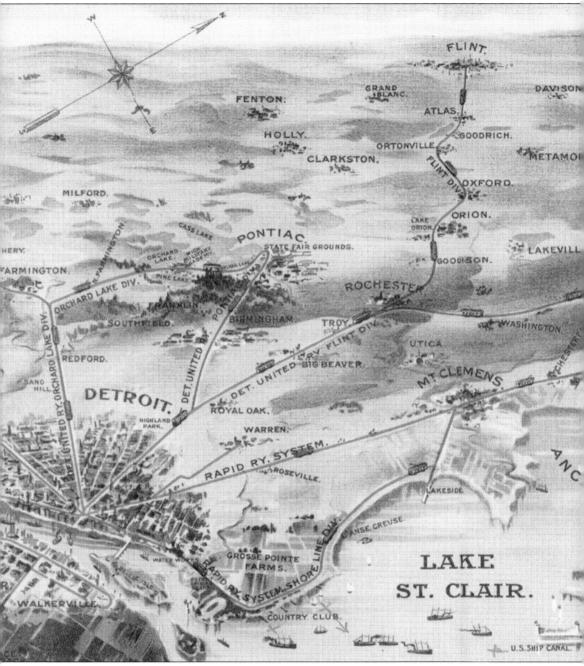

DETROIT UNITED RAILWAY'S INTERURBAN LINES.

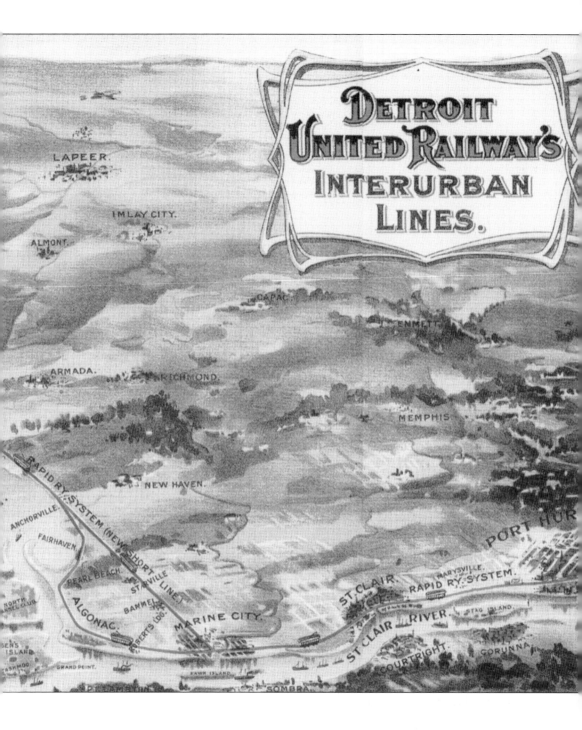

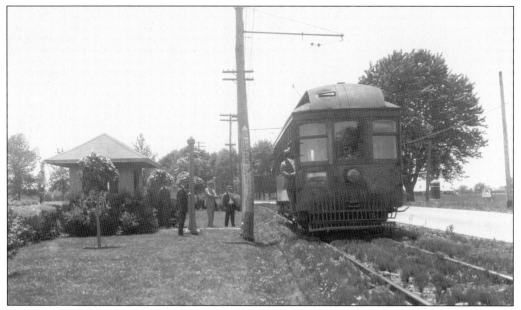

BELLEMERE STOP ON THE RAPID RAILWAY SHORELINE INTERURBAN. A typical stop on the Rapid Railway Shoreline Interurban is illustrated in this publicity photograph. Patrons boarded the Interurban cars from this small shelter on the left. Tickets were often purchased at designated houses along the route. This view is on the east side of Jefferson Avenue just south of Eleven Mile Road. Today it is the site of the public library and city hall.

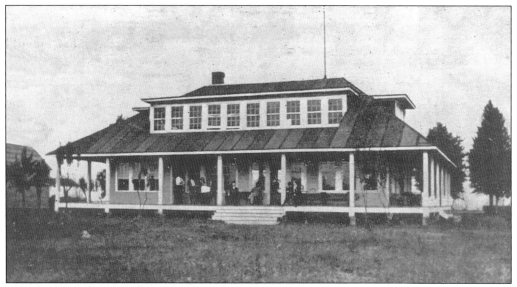

TURNER SOMMER-HEIM STATION 54 INTERURBAN STOP. The Turner Sommer-heim was a summer social club. The building became the roadhouse Britz on the Lake. It was located on the current site of the Bruce Post V.F.W.

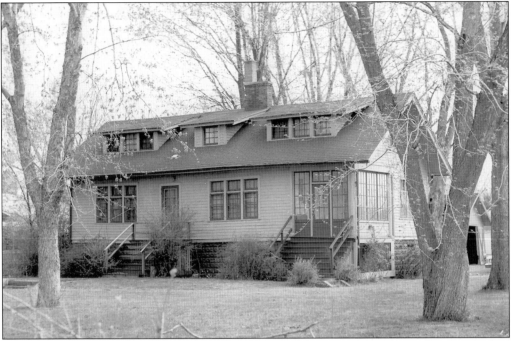

GORDON SWITCH. This house at Gordon Switch was next to the siding tracks where Interurban cars could pass each other, in order to share the single rail line. The street is still named Gordon Switch today.

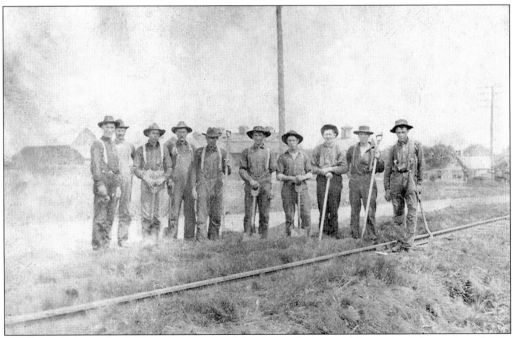

INTERURBAN WORK CREW. This photograph of a work crew on the interurban track, c. 1898, was found in the walls of the Selinsky-Green Farmhouse during restoration. The first man on the left was Henry Schwanbeck. The man fifth from the left was Bill Rivard.

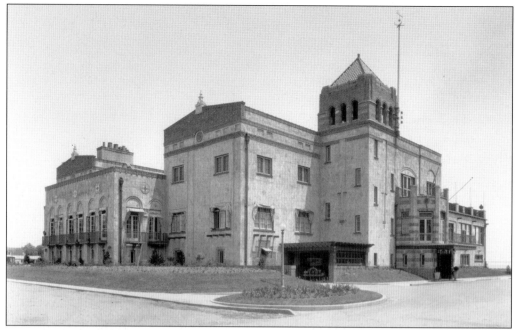

DETROIT MASONIC COUNTRY CLUB. Located at the foot of Masonic Boulevard and Jefferson Avenue, the Detroit Masonic Country Club was dedicated in May 1923. The main clubhouse had dining rooms, lounges, social rooms, billiard and card rooms, and a nursery. A large beach and play area faced Lake St. Clair.

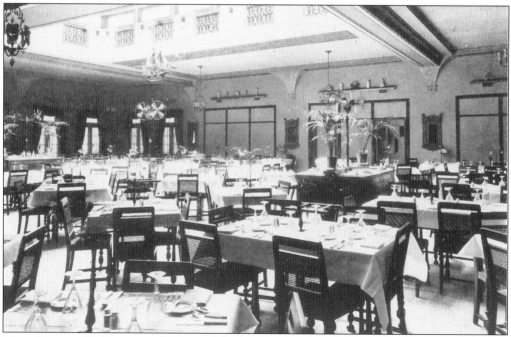

MAIN DINING HALL OF THE DETROIT MASONIC COUNTRY CLUB. The dining hall was called "El Encanto," the Place of Enchantment. During the summer, dinner dances were held every evening, with the "house" orchestra playing from 6:00 to 9:00 p.m.

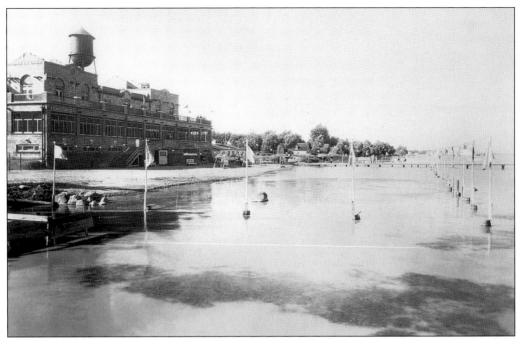

DETROIT MASONIC COUNTRY CLUB BEACH. The lakeside view of the club had a swimming area and beach, with a water slide called the "shoot-the-chutes." A covered pavilion provided shade for freighter watching. The water system for the building and golf course was a state-of-the-art water purifying system using the lake water, which was filtered by the Hygeia Filter Company of Detroit.

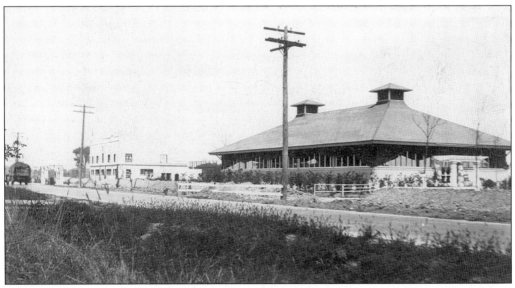

GRANDSTAND AND PAVILION OF THE DETROIT MASONIC COUNTRY CLUB. The athletic grandstand seated 800. In front were the baseball diamonds and a quarter-mile track. The Detroit Masonic Country Club athletic meets were held annually in September, sponsored by the Detroit Amateur Athletic Association. The outdoor dancing pavilion had a refreshment stand nearby for light meals.

THE COUCHEZ FAMILY FARM. From left to right, John, Constant, and Joe Couchez were photographed on their farm, which was located near Thirteen Mile Road and Harper Avenue. The Couchez family were descendants of the original French landowners in Macomb County.

VISNAW FARM SCENE. Arthur Maison is seated at the tractor with Henry Visnaw standing in front. Legend has it that they were using the windrow on the tractor to cut a new road through the fields.

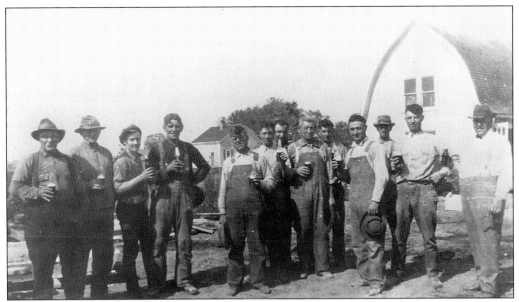

MOVING THE HENRY VISNAW HOUSE. Many houses were moved to new sites when land development occurred, rather than tearing them down. Around 1921, Henry Maison snapped this photo of the house moving crew taking a break at Henry Visnaw's place. Those in the image, from left to right, include: four Maison family members, Mr. Bohm, Mr. Fitch, Mr. Peltier, Mr. Supernault, Mr. Shook, Lathem Snay, and Mr. Plutschuck. The site was near Twelve Mile Road and Greater Mack.

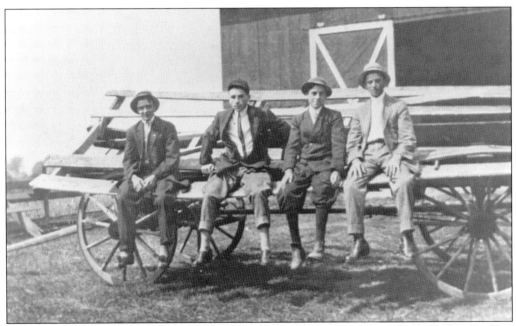

THE ALEXANDER FRAZHO FARM. Located on Jefferson Avenue, the Alexander Frazho farm was designated a centennial farm in 1974. Sitting on the wagon in front of the barn in this undated photograph, from left to right, were Art Bohnhoff, Art Frazho, Henry Frazho, and an unidentified man.

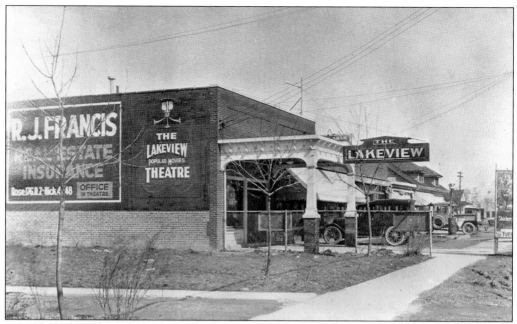

THE LAKEVIEW THEATER. Located on Jefferson Avenue at Francis Street, the Lakeview Theater was owned by Mr. and Mrs. R.J. Francis. Mr. Francis also sold real estate, and he named the streets Francis, Jewell, and Raymond after his family. In the 1930s, a ticket for a show cost 6¢. Bill Spanswich and later Harry Kraus worked as projectionists. If the kids jumped around and banged the seats, Mrs. Francis or Mrs. Kelhoffer, the candy seller, would stop the movie, turn on the lights, and the kids were reminded to "shape up or ship out." The theater closed in the late 1950s.

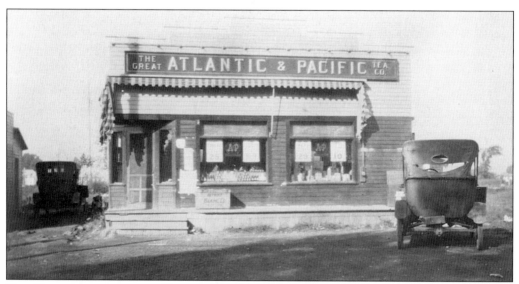

THE GREAT ATLANTIC AND PACIFIC TEA CO. This A&P market from the 1920s was possibly located on Nine Mile Road. It was one of the earliest "chain" markets in Erin Township.

MOULIN ROUGE BARBECUE. The Moulin Rouge Barbecue was the first drive-up carryout in St. Clair Shores. This photograph was taken in the 1920s. It was owned by Roy Stockwell and was known as the Dutch Mill during Prohibition. It remained a popular city landmark until it burned in the 1950s.

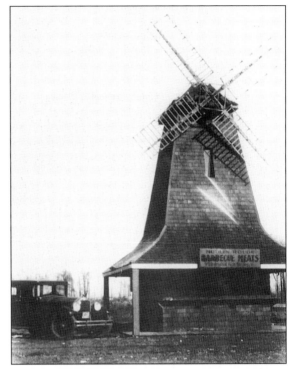

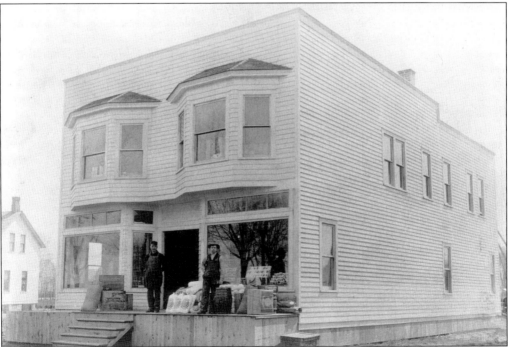

OTTO WEBER'S GENERAL STORE. Located on Nine Mile Road near Jefferson Avenue, Otto Weber's store was built in 1914. Otto Weber and Bill Fresard operated it. The top floor was a boarding house. Theresa Weber later operated it as an apartment building. The building was demolished in 2000.

MOSES AND MARTHA ALLARD. Moses M. Allard married Martha Lanstra in 1882. The couple was photographed in their winter attire in this undated image. Her property became part of the Henry Ford Estate. Her husband, Moses, was born on the site of St. Joan of Arc church. The couple had 11 children.

THE MILLENBACH FAMILY. The Millenbach Family posed on the lawn of their residence on Twelve Mile Road and Jefferson Avenue in this undated image. Besides the farm, the Millenbach family owned a hide and tallow company.

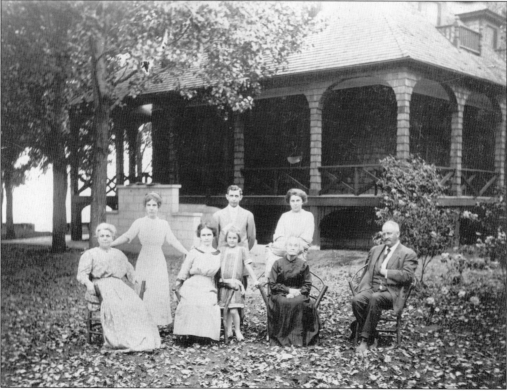

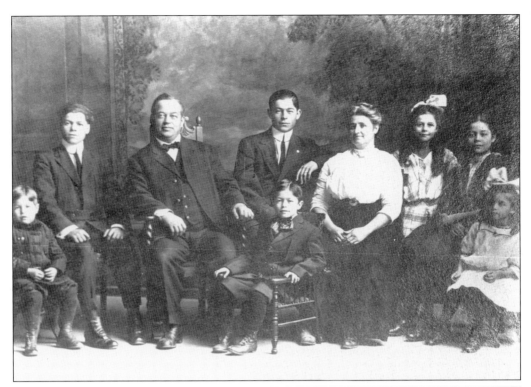

Frank A. Kaul Sr. and Family. In this image, from left to right, are members of the Kaul family: Fred, Roy, Frank Sr., Frank A. Jr., wife Mary (nee Allor), Mary, Julia (married name Maison), Martha (married name Dansbury). Seated in chair at center is Ray. The Kaul family residence and grocery store was on the site of the present-day Kaul Funeral Home, on Jefferson Avenue, operated by son Roy.

The Mutart Children. Shown in this photograph, from left to right, are the Mutart children—Irena, Bob, and Dorothy. All of the children attended the Manhattan School on Nine Mile Road. In 1928, the children were dressed up to attend a school pageant. Their mother made the dress on the left from heavy crepe paper.

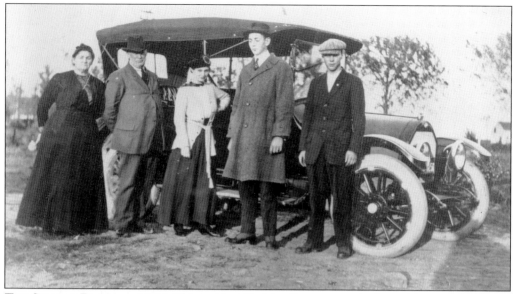

The Sunday Drive, c. 1925. This unidentified family was warmly dressed for a windy ride in their automobile with convertible top, *c.* 1925.

The Maison Family. Photographed in the family home, the Maisons were descendants of the first settlers in St. Clair Shores. They are, from left to right, as follows: (front row) Carrie (nee Maison) Trombley, Alice (nee Maison) Vernier, Victolene Maison, and Elizabeth (nee Maison) Peltier; (back row) Jim and Delius Maison with fiddles, and Gilbert Maison. Music was still a part of the French family life in the 20th century.

MRS. MARY GREEN. The Green family was among the first African-American families to settle in St. Clair Shores. Mrs. Mary Green moved here from Hamtramck, Michigan with her husband and her brothers-in-law in 1920. They lived on Collingwood Street, later renamed Robeson Street. Mrs. Green was active in neighborhood affairs, helping to get the street paved and sewers installed.

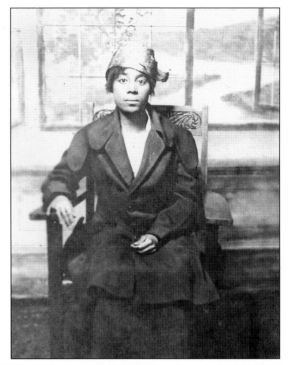

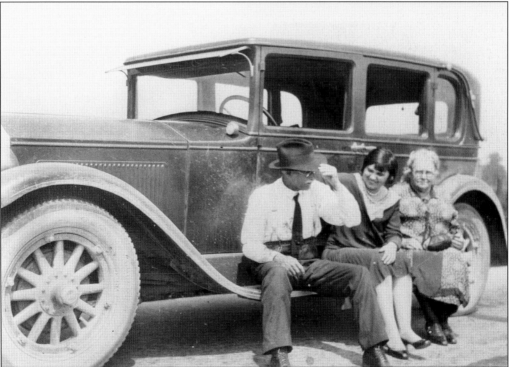

THE FRESARD FAMILY. Sitting on the running board of their automobile in the 1920s were, from left to right: Sylvester Fresard, Donna Fresard, and an unidentified woman. The Fresards were also related to early settlers of St. Clair Shores.

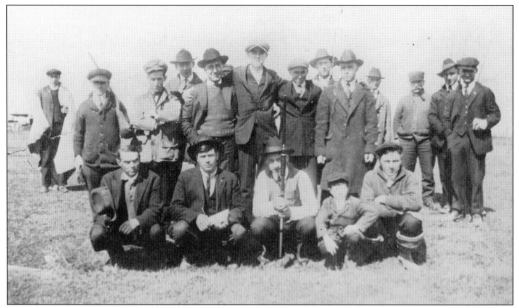

PIGEON SHOOTING CLUB. Members of the Pigeon Shooting Club posed for this portrait around 1919. The shooting range was on Twelve Mile Road and Greater Mack. The members were, from left to right, as follows: (front row) Gene Peltier, Henry Maison Sr., Archie Maison, Edwin Fox, and George Maison; (back row) Al Beste, Edward Maison, Bill Defer, Frank Millenbach, Ed Furton, Gene Millenbach, Mr. Smith, Gene Sway, Walter Furton, unidentified, Martin Maison, Louis Schock, and Francis Staubin.

FRANCIS STREET SCENE. This view of Francis Street in the Lake Shore Park subdivision was taken looking west from Kercheval Avenue (later called Greater Mack) in the 1920s. A few simple wood houses dot the landscape of this soon-to-be developed housing subdivision. Land was being cleared for building from Evergreen to Kercheval.

Three

VILLAGE YEARS
1925–1950

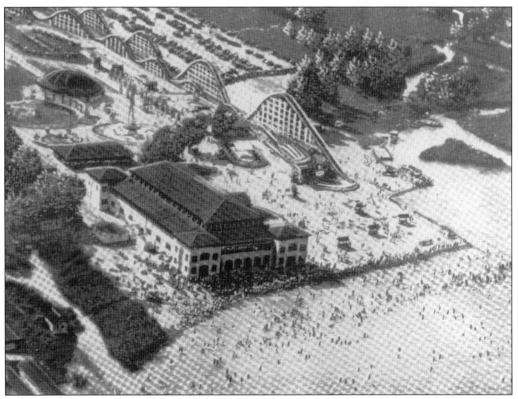

JEFFERSON BEACH AMUSEMENT PARK. Jefferson Beach Amusement Park opened in 1927 on Jefferson Avenue north of Nine Mile Road. In this aerial postcard view, the roller coaster (the longest in the country at that time), Dance Pavilion, Swing Ride, and Carousel House can be seen. The park was developed by Cyril Wagner, Fred W. Pearce, and Harry Stahl. The buildings were designed by George Haas.

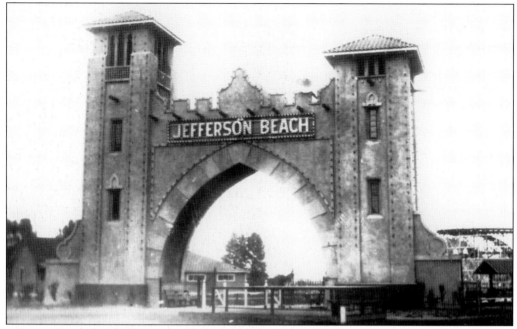

JEFFERSON BEACH AMUSEMENT PARK ENTRANCE. This landmark arch that greeted visitors at the entrance to Jefferson Beach Amusement Park was the second arch on this site and went through several design changes. This undated photograph was taken sometime after the "classic" statues of mermaids and women that adorned the arch received painted clothing, and then the offending statues were removed. The original wood arch entrance burned shortly after the park opened in 1927.

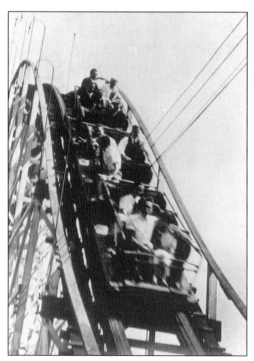

JEFFERSON BEACH ROLLER COASTER, 1933. Designed by Fred W. Pierce, the 1,000-foot long roller coaster at Jefferson Beach was said to be the longest in the country in 1927. It cost $80,000 to build. Two generations of the Pierce family had designed coasters and amusement parks. This image was taken as the cars were coming down one of the hills of the coaster.

THE "MODERN" WAY TO ADVERTISE JEFFERSON BEACH. Joe Maison showed off his fancy tire cover ad for Jefferson Beach at his home on Bon Brae Street in this 1929 photograph. Driving about the village, the tire ad was sure to attract attention.

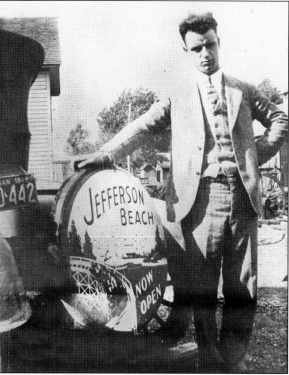

THE "SWOOPER." Jefferson Beach Amusement Park's original wheel-ride was unique because of its oval shape. A Ferris Wheel rotated and the cars swung free, but the "Swooper" did not. The cars remained stationary while steel cables pulled the seats attached to steel brackets in an oval shape. Although easy to load and unload riders, it made people queasy.

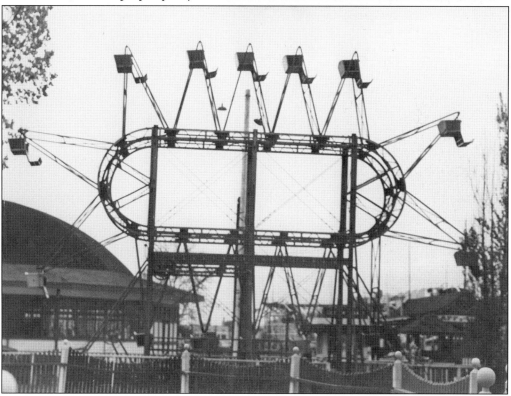

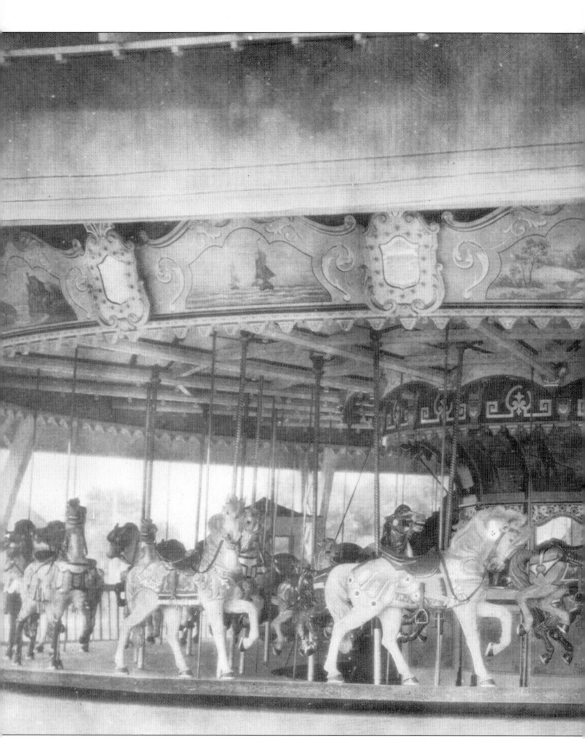

JEFFERSON BEACH CAROUSEL, 1927. This Philadelphia Toboggan Company (PTC) No. 71 carousel was purchased for $35,000 and had one golden year at Jefferson Beach. This picture was on the 1927 Jefferson Beach Park flier. The carousel was a three-row model with 48 horses and two chariots. The outer row of figures was comprised of "standers" with three hooves on

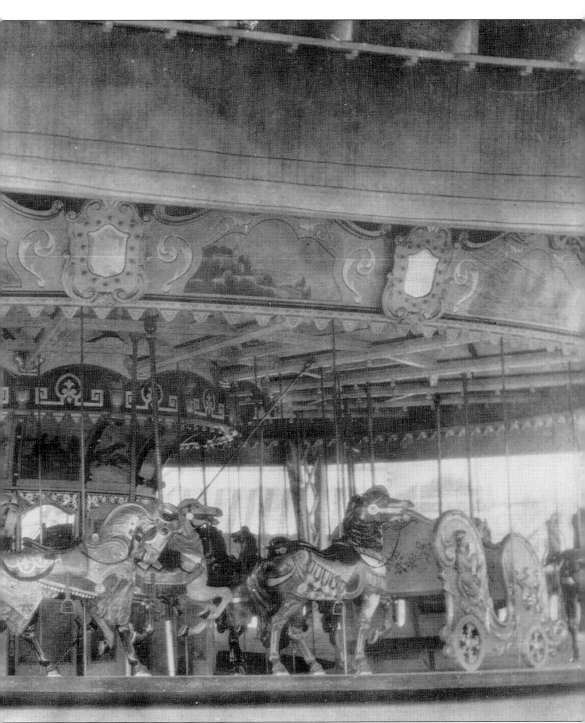

the ground and these horses did not move up and down. This carousel had a long history until the horses and chariots were auctioned in 1980 at Americana Park; later a fire consumed the carousel and building.

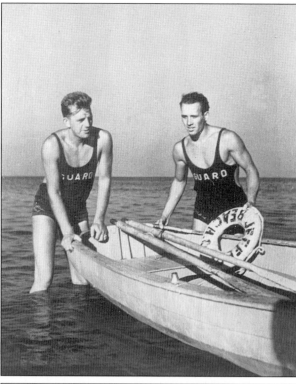

JEFFERSON BEACH LIFEGUARDS. Because of the waterfront activities at Jefferson Beach, lifeguards were a necessity. In this 1938 photograph two unidentified lifeguards display some of their lifesaving equipment, including a rowboat.

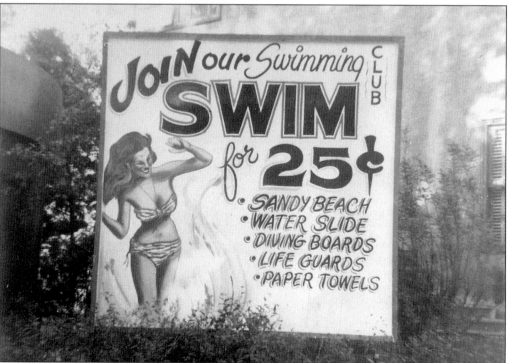

JEFFERSON BEACH SWIM CLUB SIGN. The swim club ad offered a sandy beach with waterslide, lifeguards on duty, and paper towels to clean off sand and water for the price of 25¢.

56

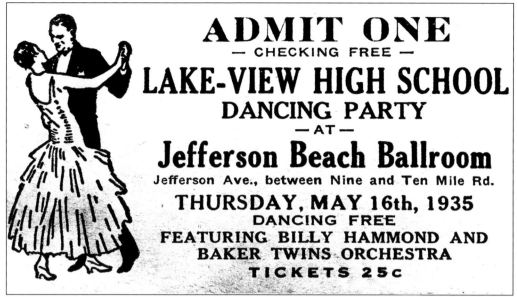

JEFFERSON BEACH DANCE TICKET. The "floating" dance floor was the main attraction at this 1935 dance in the Ballroom. The Baker Twins Orchestra supplied the Big Band sound for this Lakeview High School party.

JEFFERSON BEACH BALLROOM. George Haas, a local St. Clair Shores resident, was the architect of Jefferson Beach Amusement Park. The "floating" dance floor was supported on giant wooden beams, which gave it the unique sensation. The building was used for boat storage after the park closed in 1959. A recent fire at the Jefferson Beach Marina razed the old building.

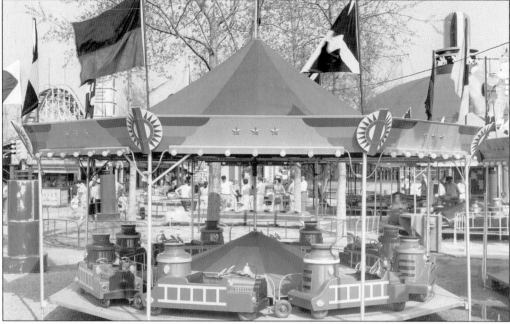

FIRE TRUCK RIDE AT JEFFERSON BEACH AMUSEMENT PARK. The fire truck ride for children was a popular attraction in the Kiddie Land section of Jefferson Beach. Manufactured by King Amusement Co. in Mount Clemens, Michigan, this company publicity photo was used to sell the rides to parks.

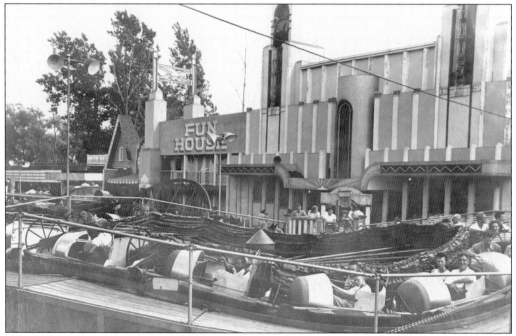

THE CATERPILLAR RIDE AND THE FUN HOUSE. Two of the popular rides at Jefferson Beach in the 1950s were the Fun House and the Caterpillar. Designed by Allan Herschell, the Caterpillar whirled under a canvas cover that resembled the bug. The ride was sold in 1959.

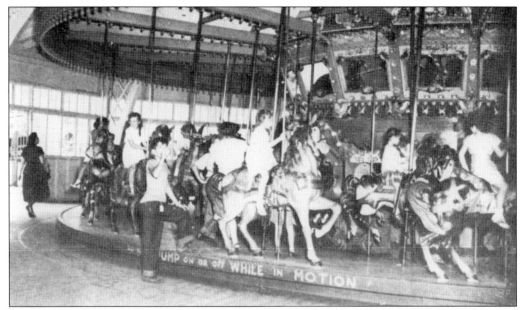

DENTZEL CAROUSEL AT JEFFERSON BEACH, C. 1940S. In 1928, the Dentzel carousel replaced the PTC No. 71 carousel, which had been sold. The Dentzel Company, founded in 1867 by Gustav Dentzel, followed the carving traditions of German carouselmakers. A three-horse carousel cost $18,000, which was substantially cheaper than the PTC NO. 71 carousel. When son William Dentzel died in 1928, Philadelphia Toboggan Co. bought Dentzel out. This publicity photo showed the wooden house constructed over the carousel and the ring of "standers" on the outside edge. Menagerie animals were included on this ride. The history of this carousel after it left Jefferson Beach is unknown.

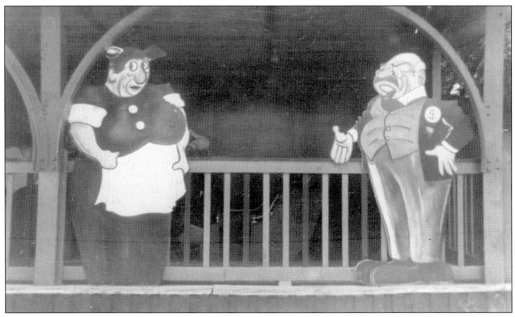

THE TUNNEL OF LOVE. Two colorful figures of a man and woman decorated the Tunnel of Love, a ride in the dark that was popular for a stolen hug or kiss. Harold Shoun designed it.

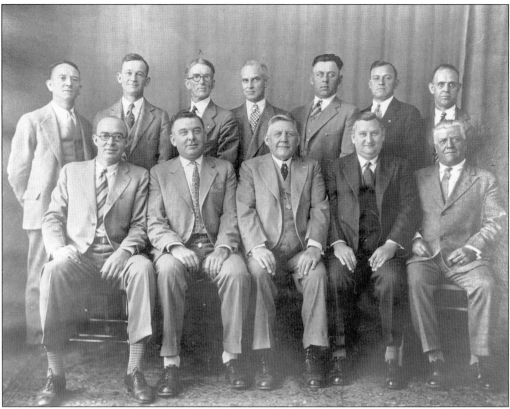

THE VILLAGE OF ST. CLAIR SHORES CIVIC LEADERS, C. 1930S. The civic leaders, from left to right, are as follows: (front row) David Visnaw, Raymond Francis, Daniel Davis, Frederick Kaess, and Harley Swacick; (back row) Joseph Johnson, Clayton Beveridge, Tom Daly, Robert Moore, Edward Kurtzhals, Lester Grimshaw, and Mr. Dean.

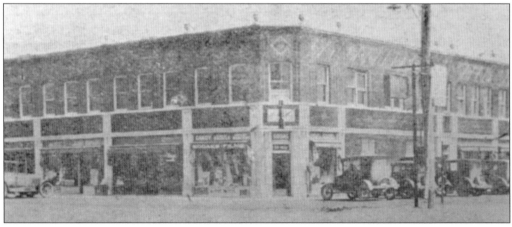

THE DAVIS BLOCK, 1928. The Davis Block, located at Harper Avenue and Town Hall Road (Eleven Mile Road) was one of several retail areas in the village. Sid Read's Drug Store occupied the corner of the block. On the Harper Avenue side were Vornberger Hardware, Nelson Dry Goods, and Ralph's Market. The Masonic Lodge met upstairs. On the Town Hall Road side were the Fred Davis Gas Station and auto parts store, and the St. Clair Shores Police Station.

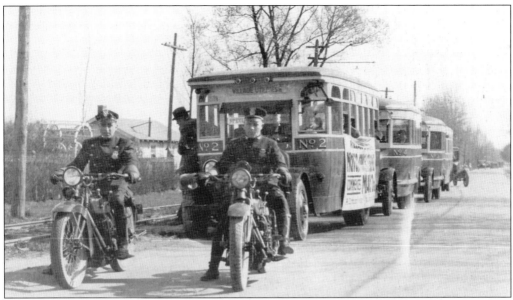

VILLAGE UTILITIES INC. BUS COMPANY FIRST DAY OF SERVICE. Motorcycle police Harvey Champine and Harold Lanstra escort the new Village Utility Busses, two REO and a Dodge-Graham model, on Jefferson Avenue. The first day of service was May 2, 1927. The bus service replaced the interurban service, which officially ended May 26, 1927.

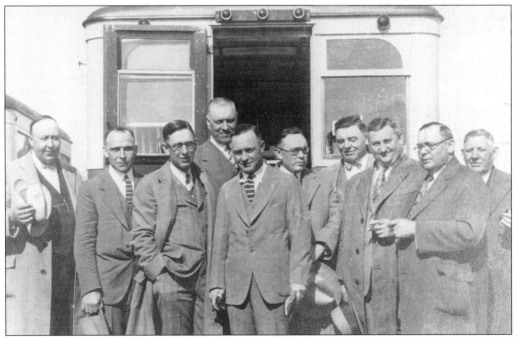

BUS COMPANY OFFICIALS IN 1928. These bus officials in 1928 are, from left to right, as follows: Henry Visnaw, George Bidigare, unidentified, unidentified, George Haas, Fred McGraw, Raymond Francis, Fred Case, Lloyd Hillock, and Daniel Davis. In 1932 Detroit Motor Coach went out of business in Detroit; Village Utilities was a subsidiary of this company. A new company, Lakeshore Coach Lines, Inc., was formed which operated until purchased by SEMTA in 1971.

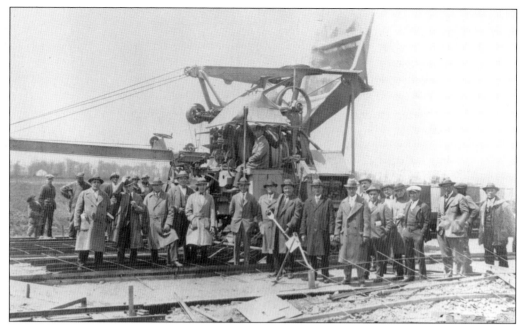

FIRST PAVED HIGHWAY IN ST. CLAIR SHORES. The Harper Lake Township Improvement Association was instrumental in paving Harper Avenue with concrete, the first paved road in the village. The 30-foot wide pavement running through Lake Township cost $500,000. The groundbreaking ceremony was recorded in this image with members of the Association and Macomb County Road Commission present. D.N. Davis, Association President, wields the shovel.

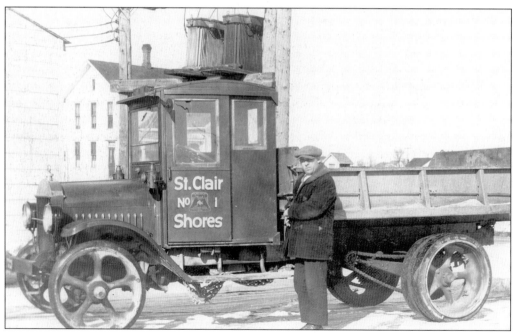

FIRST D.P.W. TRUCK, 1926. Edward Kurtzhols stands by the first Village of St. Clair Shores dump truck in 1926. According to the *Nellis News* of 1928, the month of May was the annual cleanup of the village, with residents stacking garbage together so the rubbish trucks could pick it up.

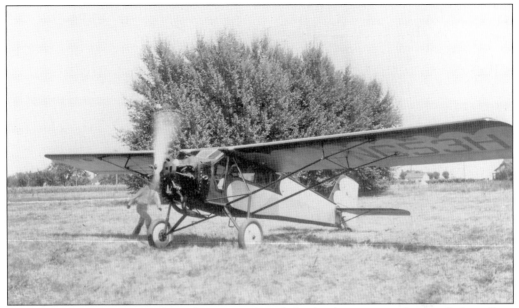

ARDMORE AIRPORT. Several small airports dotted the landscape in and around the village of St. Clair Shores. This Airport was located at 10 1/2 Mile and Jefferson Avenue and ran to the lake. This is a photo, taken August 13, 1933, of a Curtiss Robin plane with a six-cylinder Challenger engine that took passengers for flights over Lake St. Clair and the shoreline. The plane was silver with red trim.

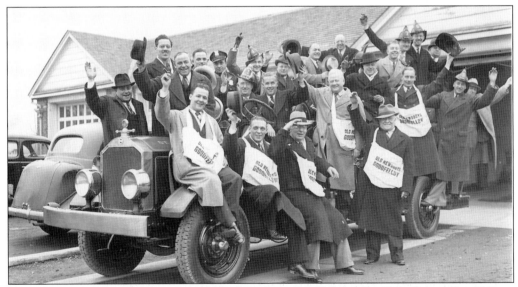

OLD NEWSBOYS GOODFELLOWS OF 1936. Tom Daly founded the St. Clair Shores Goodfellows chapter in December 1925. The St. Clair Shores Goodfellows posed on the fire truck at the fire station in 1936. They are, from left to right, as follows: (front row) Emerson Belmore, Reg Rivard, David Visnaw, and Harley Swazik; (middle row in truck) Chet McCracken (in helmet), Don Warrow, Otto Hughn, Roy Kaul, Jerry Adams, and Carl Worden; (back row) Harold Lanstra (wearing hat), Bruce Calkins, Les Gramshaw, Charlie Perkins, Harvey Champine, George Geary (in helmet), Walter Pratt, Karl Wile, Ed Brown, Bob Kuhn, Bill Adamek, and Milt Sicklesteel.

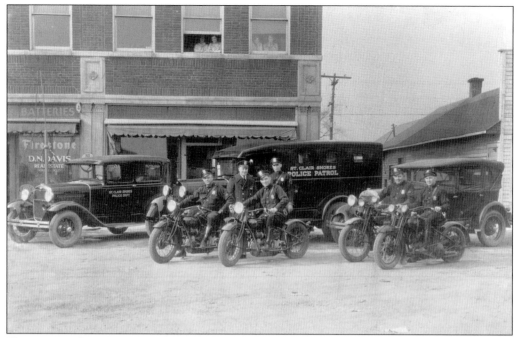

VILLAGE OF ST. CLAIR SHORES POLICE. Headquartered at the Davis Building at Town Hall (Eleven Mile Road) and Harper Avenue, the Village Police Department patrol cars, ambulance, and motorcycles were displayed in this 1931 photo. The police officials, from left to right, are as follows: Trufley Dubey, Chief Harold Lanstra, Phillip Eckhout, Harvey Champine, Charles Nelson, and Jim Trombley. The police department was organized in 1926 with the formation of the village.

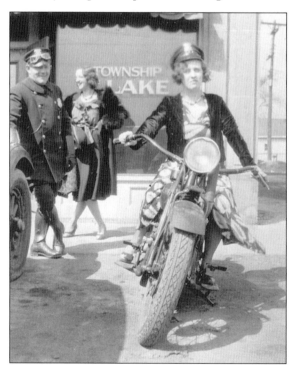

LAKE TOWNSHIP MOTORCYCLE MAYHEM, 1926. "Flappers" Trixie and Dido trying out Officer Harold Lanstra's motorcycle at the Lake Township Police Station in the Davis building. Mildred Sullivan, also known as "Dido," continued to have an affinity for motorcycles as she grew older.

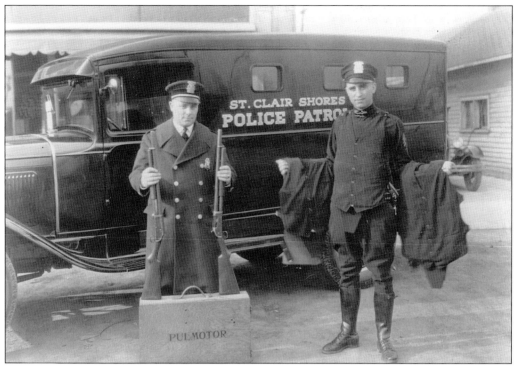

VILLAGE OF ST. CLAIR SHORES POLICE DEMONSTRATE NEW EQUIPMENT. From left to right, Chief Harold Lanstra with the Pulmotor resuscitator and shotguns, and Harvey Champine with bulletproof vests stand in front of the Police ambulance in 1931.

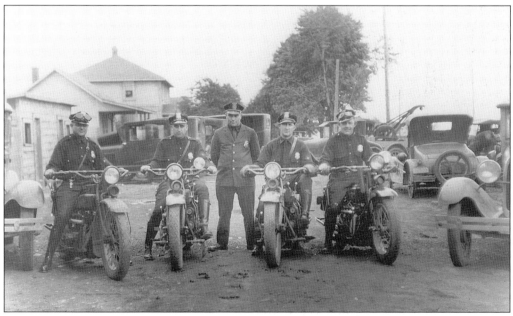

VILLAGE OF ST. CLAIR SHORES MOTORCYCLE PATROL IN 1928. On motorcycles in the police yard behind the Davis Block station on June 19, 1928, from left to right, are: Trufley Dubey, Harvey Champine, (standing) Chief Harold Lanstra, Jim Trombley, and Jim Nelson.

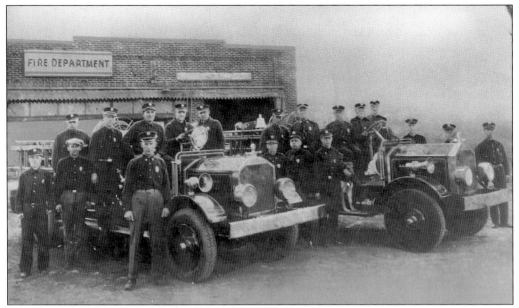

VILLAGE OF ST CLAIR SHORES FIRE DEPARTMENT, 1928. On October 28, 1928 the Village Fire Department and mascot dog assembled for this group photo at the north end station at Jefferson Avenue and Avon Street. Standing by the left truck, from left to right, are: Ken Bell, Norm Whiting, Chief James Stapleton. On left truck itself are, from left to right: Harvey Burke, John Koepsell, Captain Jim Bell, Ed Bell, and Dave Meldrum. Standing by the right truck are, from left to right: George Springer, George Supernaugh, and Wesley Nesky. On the right truck, from left to right: Ed Trombley, John Boyd, L. Vincent, Tom Dickman, Roy Vernier, Clarence Vernier, Otto Robel, and Clarence Lacey. John Boyd was killed on duty in November 1928.

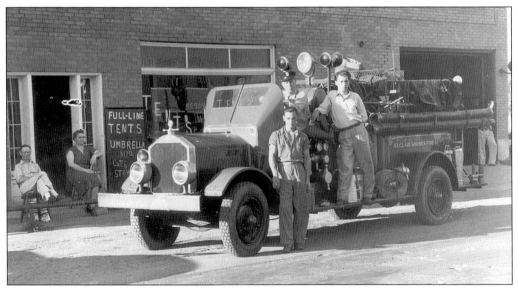

ENGINE CO. NO. 2 IN THE EARLY 1940S. The No. 2 station was located at Greater Mack and Nine Mile Road in the 1940s, on the present site of Roy O'Brien Ford Dealership. Standing in front is Howard Hartman. Capt. Byron Miller is behind the wheel and Joseph Mulcahy is on the running board. Notice the camping supply rental next door.

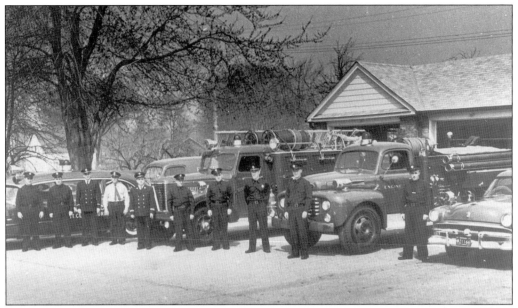

VILLAGE FIRE DEPARTMENT AT ELEVEN MILE AND JEFFERSON IN THE 1940S. These firefighters have been identified standing in front of the ambulance, high pressure truck, and pumper truck: Jerry Hardy Sr., Johnny Ploe, Mr. Milater, John Debusscher, Art DeWashy, Pat McKenny Sr., Art Hoffman, and Dave Rinehart.

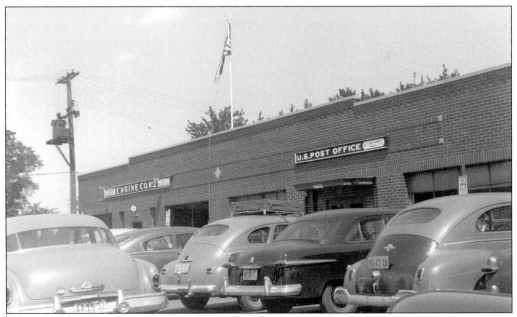

ST. CLAIR SHORES ENGINE CO. NO. 2 STATION, 1952. After St. Clair Shores became a city in 1951, this photo was taken of Engine Co. No. 2. The station was sharing a building with the U.S. Post Office.

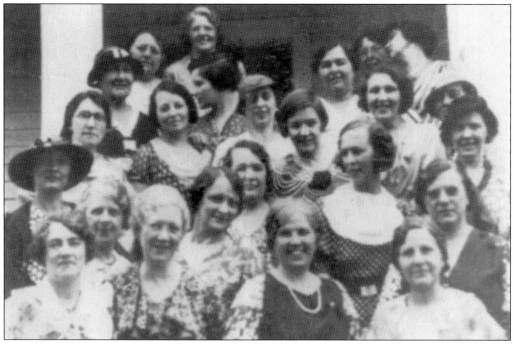

THE ST. CLAIR SHORES STUDY CLUB, 1933. This group portrait of the St. Clair Shores Study Club was taken on the steps of the home of Mrs. Otto Huhn in 1933. Mrs. Charles Olmstead was president that year. A roster of the original members is on record at the St. Clair Shores Public Library. Founded in 1931, this club subsequently became the St. Clair Shores Women's Club, who sponsored the first library in the Municipal Building, which opened September 27, 1935. Over 500 books were collected at the home of Mrs. Russell Srigley, study club president that year. A memorial garden at the library honors the club's dedication to the community.

THE CITY OF ST. CLAIR SHORES MUNICIPAL BUILDING, C. 1970S. The Municipal Building, located on the corner of Eleven Mile Road and Jefferson Avenue, was on the site of the present district courthouse. The inner walls of the court are part of this original building. The city's first library was a room in this building in 1935. Mrs. Ida Hanson was the first appointed librarian.

THE ST. CLAIR SHORES PUBLIC LIBRARY (1943–1959). Located on Eleven Mile Road and Jefferson Avenue, the old Lakeshore Presbyterian Church had been purchased for $300 and moved to this site from Grove Pointe to become the Library's second home in May 1943. Mrs. Delia Waldner was appointed librarian in 1942. On Saturday, January 11, 1947, the first children's story hour was held.

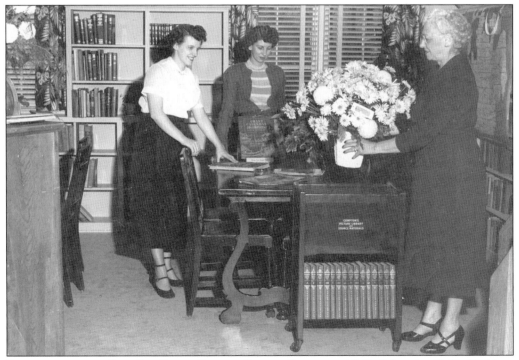

INTERIOR OF THE OLD ST. CLAIR SHORES PUBLIC LIBRARY, 1943. Librarian Delia Waldner arranges flowers in the adult reading room.

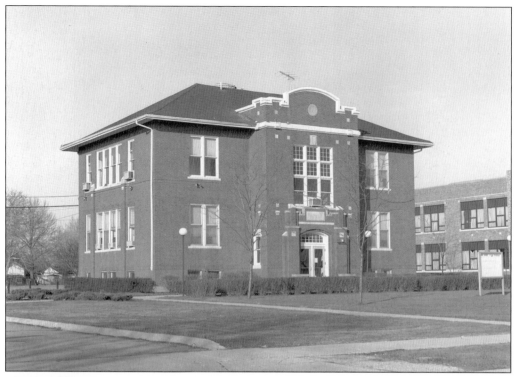

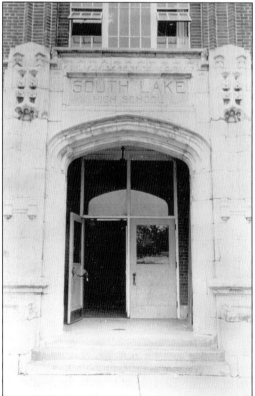

LAKE SHORE PUBLIC SCHOOL. In 1910, Lake Township District No. 3 was formed at the north end of the Avenue. The two-story brick Lakeshore school was built on 13 Mile Road near Jefferson in 1917. It was razed in 1981.

ENTRANCE TO OLD SOUTH LAKE HIGH SCHOOL. South Lake High School was constructed in 1924 on Nine Mile Road and Greater Mack. An addition designed by local architect George Haas was added in 1927. Approximately 420 students attended school here in the mid-1920s.

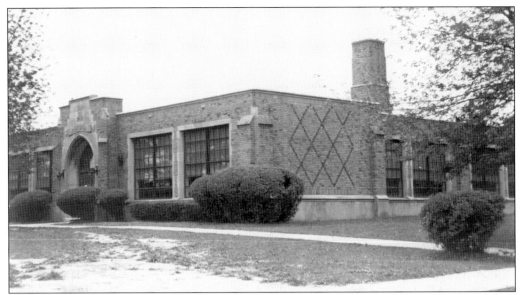

WHEAT SCHOOL, 1952. Designed by architect George Haas, Wheat School was constructed on Harper Avenue south of Eleven Mile Road on part of the original Wheat family farm. It had four classrooms in 1926. An addition was built in 1952 that included two classrooms, kindergarten, multi-purpose room, and kitchen. Benjamin Wheat had organized District No. 5 School in 1850, which had 18 students at that time.

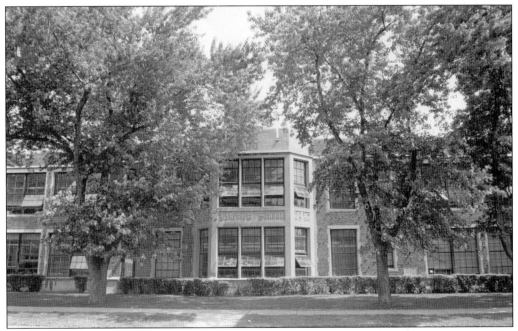

LAKEVIEW SCHOOL, 1982. Designed by George Haas, the Lakeview School, built in 1926, was also called Chippewa Junior High in 1954 and Jefferson Junior High in 1979. It stood on the site of the present Bon Secours Nursing Center. The gymnasium and band building were built into the new facility. Built with steel window frames, ornate brick, marble bathroom walls, and terrazzo floors, it was a well-built school of its day.

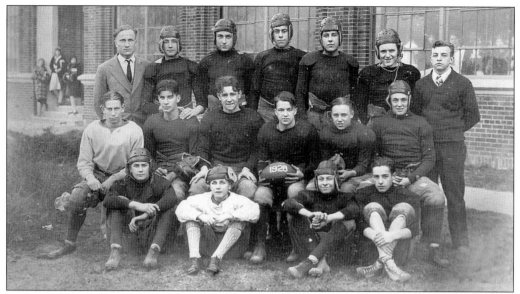

SOUTH LAKE FOOTBALL TEAM, 1928. Coach Ralph Carpenter posed with his 1928 football team on the South Lake School lawn. They are, from left to right: (front row) Charles Defer, Ernie Dallier, B. Attoway, and F. Henretta; (middle row) Russ Pare, Ray Clave, Chuck Steins, F. Labadie, Donald Blumenthal, and C. Demus; (back row) Ralph Carpenter, H. Ottenbein, L. Smith, D. Turrell, R. Clave, R. Martin (or W. Chase), and G. Baeckeroot.

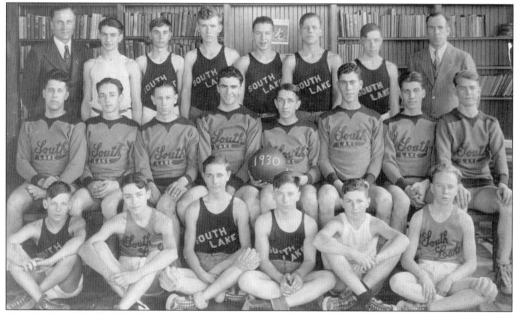

SOUTH LAKE BASKETBALL TEAM, 1930. Coaches Ralph Carpenter and George Steketee posed with the 1930 South Lake basketball team. They are, from left to right, as follows: (front row) C. McKee, C. Clark, E. Dallier, F. Maitland, J. Keras, and R. McArthur; (middle row) R. Clave, F. Henretta, R. Pare, W. Chase, H. Otterbein. D. Turrell, R. Clave, and C. Defer; (back row) Coach Ralph Carpenter, J. Walleman, K. Shepherd, F. Goodenough, O. Hallison, T. Reynolds, and Coach George Steketee.

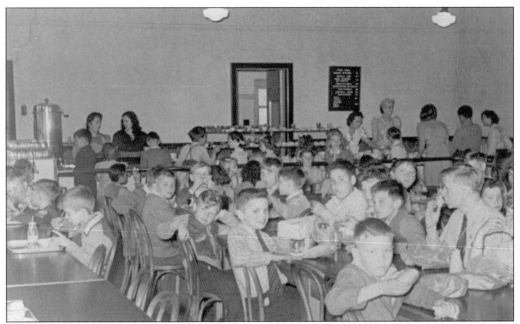

SOUTH LAKE ELEMENTARY CAFETERIA, C. 1943. Here is lunchtime at Southlake Elementary school, which was located on Nine Mile Road west of Greater Mack. The neatly dressed boys were wearing shirts and ties. Some students have sack lunches and some have school lunch trays with glass milk bottles.

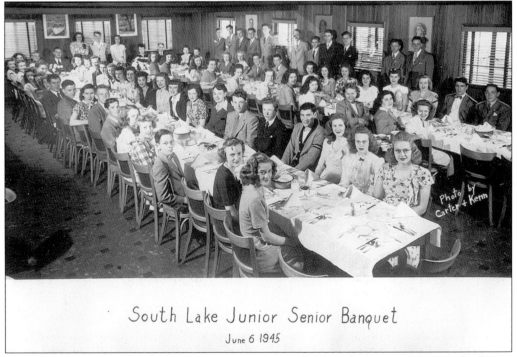

South Lake Junior Senior Banquet

June 6 1945

SOUTH LAKE JUNIOR SENIOR BANQUET, 1945. A school tradition in 1940s was the Junior Senior Banquet before graduation.

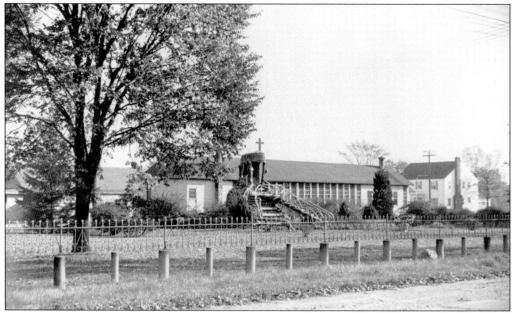

OLD ST. JOAN OF ARC CHURCH AND SHRINE (1928–1943). The first St. Joan of Arc Roman Catholic Church was created from two sections of the old wood frame of Wheat School which was moved from Harper Avenue and Town Hall Road (Eleven Mile Road) to Greater Mack and Overlake Street. It was called the "chicken coop" church because of the building's shape. Mexican artisan Dionysius Rodriguez under the supervision of Fr. Fillion built the stone shrine to St. Joan. Lights and a 1200-gallon-per-hour waterfall added to the beauty of the shrine.

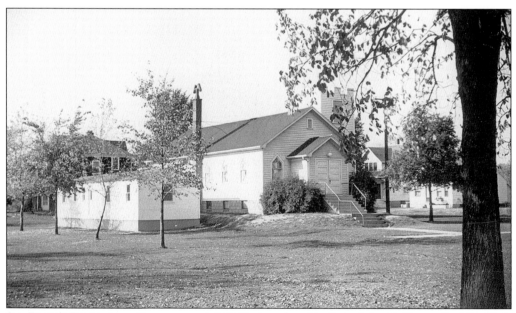

ST. PAUL'S LUTHERAN CHURCH, C. 1945 Designed and built by John E. Koepsell of St. Clair Shores in 1926, the frame chapel with the Tudor-Gothic tower was located at Greater Mack and Colony Street. The church was later moved to Eight Mile Road and I-94 when the new church was built. It is presently used as a resale shop by another church.

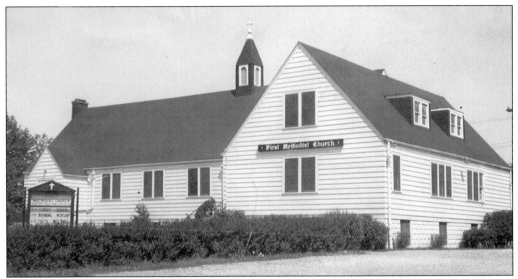

FIRST METHODIST CHURCH, 1952. The First Methodist Church was built around 1932 at Greater Mack and Ridgeway Street. The nephew of Reverend L.F. Rayfield, nine-year-old Jack Veale, planted the idea of a Methodist church in St. Clair Shores instead of riding to Detroit for services. A storefront and a garage were used at first for services. Reverend H. Burden laid the cornerstone in 1930.

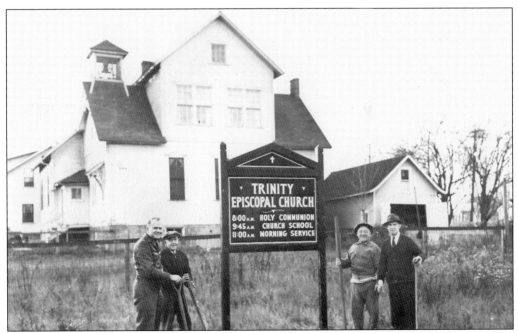

OLD TRINITY EPISCOPAL CHURCH, 1945. From left to right, Reverend James Carson, Clyde Skinner, Bill Tachell, and James Mahon erected the church sign. Located at Jefferson Avenue and Lake Boulevard, Trinity, the first Protestant church in St. Clair Shores, was originally built from the structure of a wood-frame school, which was moved to the site around 1919. A parish hall was added to the church in 1922. The church was razed in 1964, when the present church was constructed.

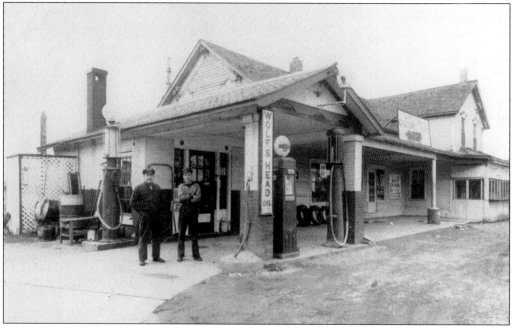

PAULEY'S SERVICE STATION, C. 1930s. George Pauley (left) and Floyd Spear (right) are waiting to service your auto at 29157 Jefferson Avenue near Corteville Street. The tall Charm visible gas pump and the High-Speed visible pump date from the late 1920s. The High-Speed sight globe pump is next to the Wolf's Head oil sign and dates from the early 1930s. Hot dogs were 10¢-a-foot at the drive-up window. Next door was the Lakeshore House Tavern, now Cosimo's Lakeshore House.

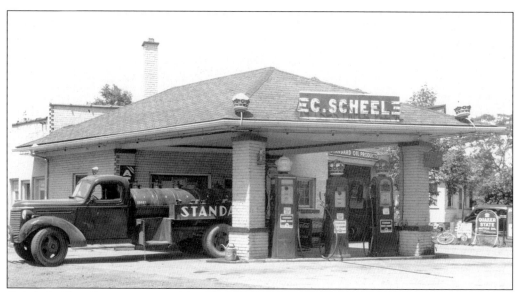

SCHEEL'S GAS STATION, C. 1930s. The Standard Oil gas truck is parked at Scheel's station during the 1930s. This station was at Jefferson Avenue and Beverly Street. It had two repair stalls and three metered pumps which measured fuel and shut off the flow automatically. Presently it is a bicycle shop.

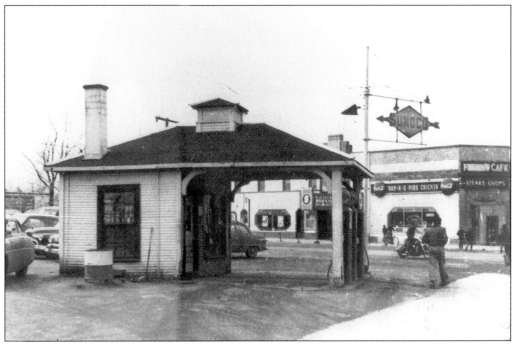

TREMPER'S SUNOCO SERVICE STATION, C. 1940S. Located at Greater Mack and Nine Mile Road, Tremper's Service was a three-pump station with no garage. Tires and batteries were serviced. This was a simple drive-up station with an overhang, similar to modern covered pumps today.

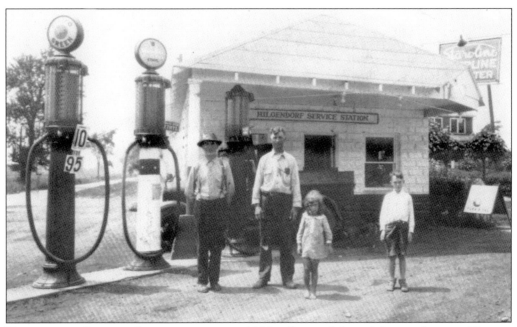

HILGENDORF SERVICE STATION, C. LATE 1920S. Pictured from left to right, are: Herman Hilgendorf, John Maison, Helen Maison, and John Maison Jr. The station was at Jefferson Avenue and Laukel Street. The three visible pumps sold Green Gas and Ethyl.

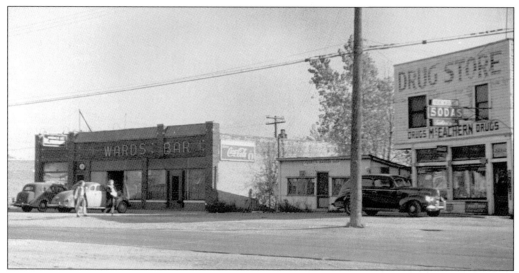

STORES AT NINE MILE AND SOUTH SIDE OF MACK, C. 1940s. Ward's Bar was run by Everett and Evalyn Ward, and boasted two billiard tables. The small wood building next door had once been a barbershop and was often vacant. Chet McEachern's Drug Store had a small soda bar. The drug store was next to the Tremper Service Station.

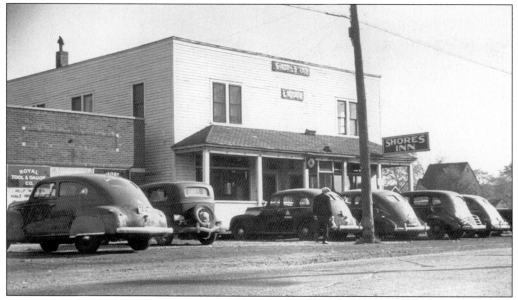

SHORES INN, C. 1940s. The first liquor license in St. Clair Shores after Prohibition belonged to the Shores Inn. Ernest McCollum was the operator of the landmark inn on Greater Mack. In 1928 St. Joan of Arc held services there while the first church was being built. The Shores Inn is still in operation as of 2001.

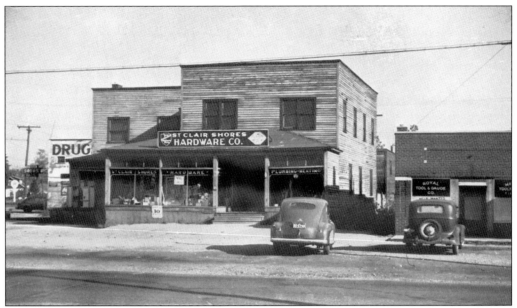

NINE MILE AND MACK STORES, C. 1940S. Down the block from the Shores Inn was the Royal Tool and Gauge Co. On the corner of Greater Mack and Nine Mile Road was St. Clair Shores Hardware, operated by Jack and Aggie Sheldon.

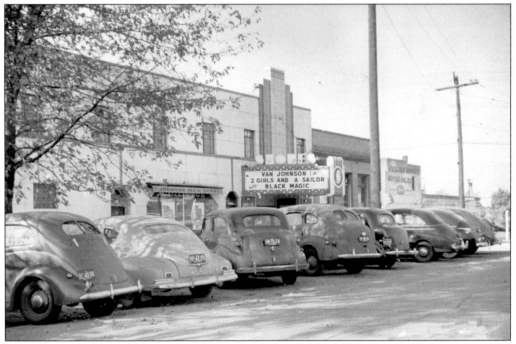

THE SHORES THEATER, 1944. Van Johnson was starring in "Two Girls and a Sailor" in this 1944 photo of the marquee of the Shores Theater. When the theater opened in the 1940s, tickets cost 6¢ for kids. It is still in operation as a family theater in 2001.

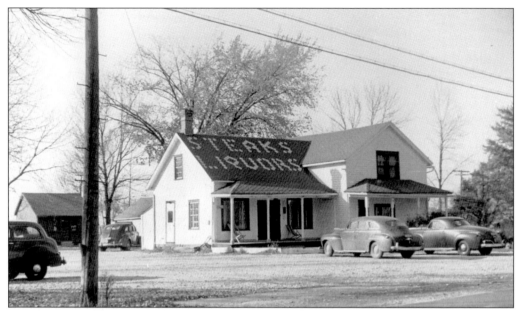

DRISCOLL'S STEAK HOUSE, C. 1940s. One of the oldest landmarks in St. Clair Shores, this farmhouse was originally Labadie's Grocery on the west side of Jefferson Avenue at Labadie Road (Ten Mile Road). Nelson and Theresa (Marach) Labadie were the proprietors. In 1923 John and Helen Bennett ran the store for the Labadies until Mrs. Labadie died and Pete Labadie took over the business. The farmhouse became Driscoll's Steak House in the 1940s. Bobby Moore's Steak House and the Blind Fish occupied it in the 1980s and 1990s until the restaurant was destroyed in a fire.

MARGOLIE'S INN, 1912. Located on Jefferson Avenue north of Nine Mile Road, Margolie's was a popular roadhouse. It was on the current site of Big Boy's restaurant. Margolie's was reputed to be a "Blind Pig" (a speakeasy where illegal liquor was sold) during Prohibition.

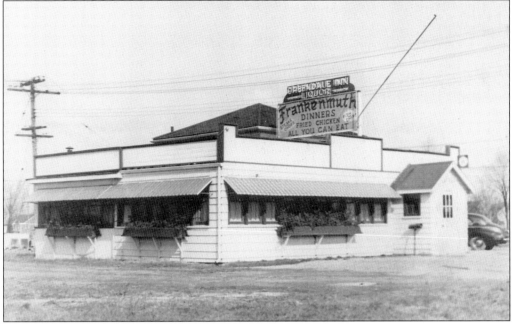

GREENDALE INN, C. 1940S. Located at 27609 Harper Avenue near Eleven Mile Road, the Greendale Inn was a popular spot for all-you-could eat fried chicken and a beer.

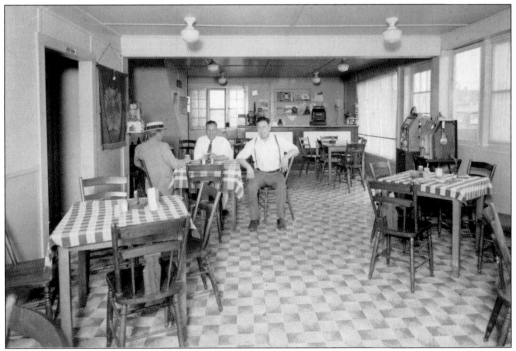

INTERIOR OF THE GREENDALE INN, C. 1930S. Three gentlemen sit at a table across from a pair of slot machines. One-armed bandits were a common sight in roadhouses and bars—to try your luck and win a buck or two. Gambling was a common problem during and after Prohibition for the local police. Leon Delo and Al Witrick owned the Greendale Inn in the 1930s.

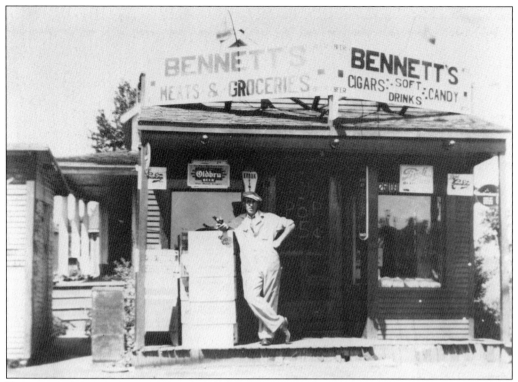

BENNETT'S MARKET, C. 1931. John and Helen Bennett moved their store from Labadie's in 1923 to a small building, which was later the site of Jim's Barber Shop, located on Jefferson Avenue just north of Ten Mile Road. This photo is the first day 3/2 beer was available at the end of Prohibition. Ice cream cones were a nickel and the smell of fresh coffee from the grinder filled the air of the store. The Bennetts later built a larger store on the next door lot.

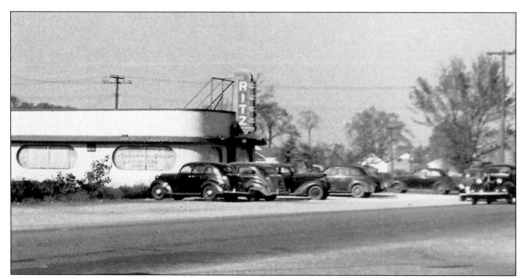

THE RITZ BAR, C. 1940S. Located on Nine Mile Road and Harper Avenue, the Ritz Bar was a landmark in St. Clair Shores since Prohibition.

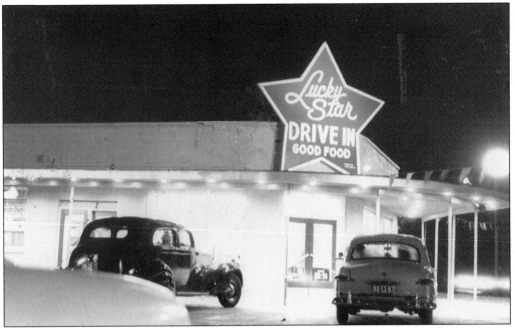

LUCKY STAR DRIVE-IN, C. 1940S. This is a night shot of the Lucky Star Drive-In at Nine Mile Road and Harper Avenue in the 1940s. Cruising, milk shakes, hamburgers, and meeting friends were a part of the social life of the drive-in during the 1940s and 1950s.

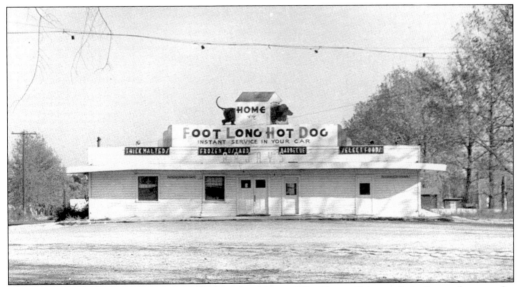

ARJAY'S, C. 1940S. Located on Jefferson Avenue at Blackburn Street, Arjay's was known for the doghouse roof sign proclaiming it the "home of the foot long hot dog." The owner was R.J. Williams. Arjay's was in business from the 1920s and was later moved to this location near to Jefferson Beach Amusement Park.

THE ROY O'BRIEN "JINGLE". "Get on the Right Track! To Nine Mile and Mack" sang the Gaylords on the radio ads. The jingle was written by Ron Gaylord and Burt Holiday in the 1950s and is still in use in 2001. Roy O'Brien Sr. opened his Ford automobile dealership in 1946.

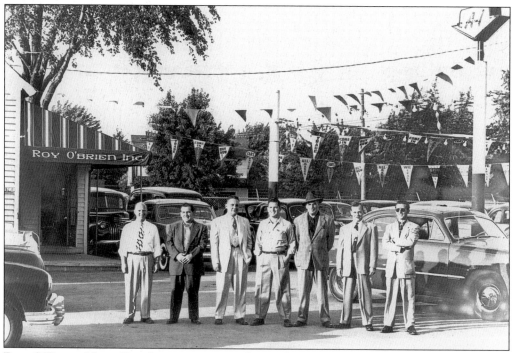

ROY O'BRIEN USED CAR LOT, C. 1940s. The used car sales team stands ready to sell you a Ford in this 1940s photo of the sales lot.

ROY O'BRIEN FORD DEALERSHIP, C. 1946. The original building on Nine Mile Road and Greater Mack had been the Village of St. Clair Shores fire station, a camping supplies rental business and Strom's Furniture Store. The repair garage sign proclaims "open to 10 p.m."

FORD DEALERSHIP PROMOTION, C. 1940S. Children are enjoying ice cream and Vernor's Ginger Ale at an auto sales promotion, while Dad shops for a vehicle in the showroom in this 1940s photo at Roy O'Brien Ford.

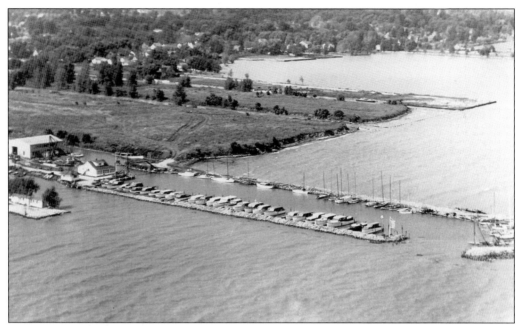

Miller Marina. This is an undated aerial view of Miller Marina located at 24770 Jefferson Avenue on Lake St. Clair. The sailboats used one side of the marina and powerboats used the other. Originally called Shores Boat Harbor in the 1930s, it was the first marina in St. Clair Shores. Bill Miller developed the marina.

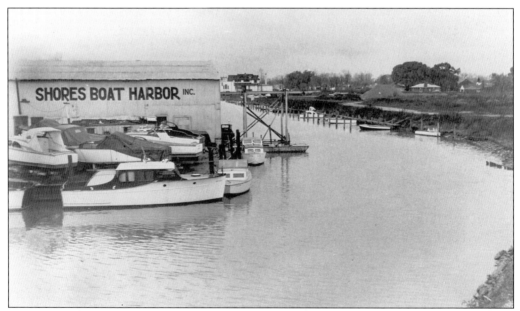

Shores Boat Harbor. Entering the marina from Lake St. Clair the boat storage building on the left marked the way in to the quiet harbor and the shore. A classic wood cabin cruiser is docked on the left.

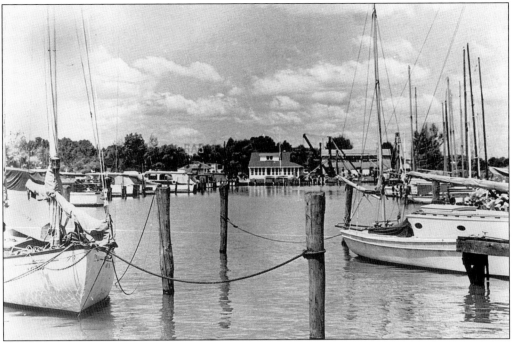

VIEW OF SHORES BOAT HARBOR. Another view of the marina basin, showing the yachts on one side and power boats on the other side of the docks. The marina scene typifies the boating and recreation along Lake St. Clair.

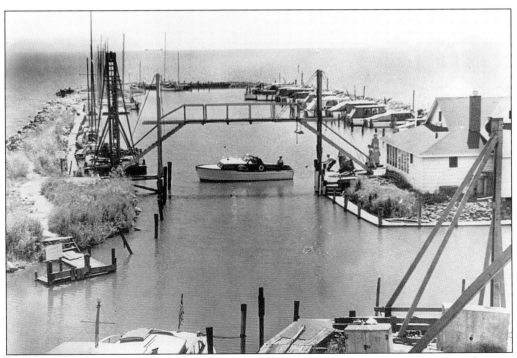

VIEW OF SHORES BOAT HARBOR. A classic wood-cabin cruiser is moving under the pedestrian overpass, which spanned the marina.

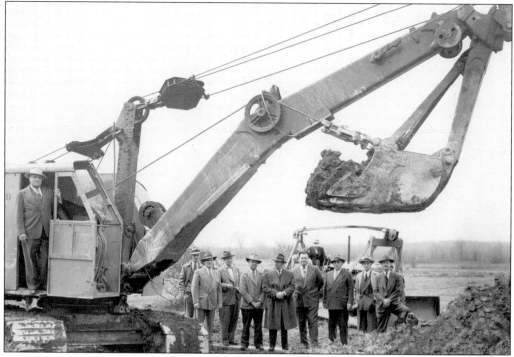

LAKE SHORE VILLAGE. On April 24, 1948, ground was broken for the new Lake Shore Village development by the Hayes Developing Co. Located on Lakeshore and Marter Road, the complex of townhouses was quickly ready for occupancy to match the growing population of St. Clair Shores following World War II.

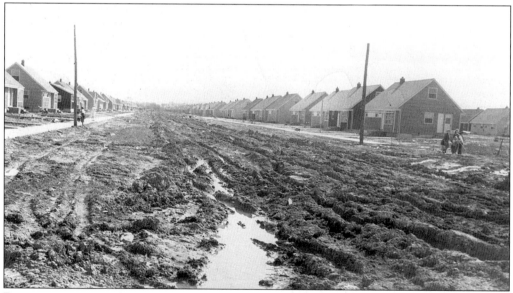

BEACONSFIELD OR "MUDVILLE" IN 1948. Muddy unpaved streets were a reality as the rows of bungalows and ranches were quickly built to supply housing for the new residents of St. Clair Shores. This is Beaconsfield looking south from Twelve Mile Road. In the 1950s the I-94 freeway construction took some of these houses.

Four

CITY YEARS
1951–2001

FIRST CITY OF ST. CLAIR SHORES OFFICIALS GROUP PORTRAIT, 1951. Taking office on January 15, 1951, at the city offices in Blossom Heath were, from left to right: (sitting) Councilmen Milton E. Sickelsteel Jr., Nicholas R. Kerns, William D. Warfield, and City Attorney John H. Yoe; (standing) Justice of the Peace Herman Brys, Councilmen John W. Lenders, Edward R. Brown, Robert E. Harrison (the first mayor), and Thomas S. Welsh.

ST. CLAIR SHORES CIVIC CENTER, 1952. On February 25, 1946, the Village of St. Clair Shores completed the purchase of Blossom Heath Club from owner Harold Walden to convert the building into a civic center. Over 150 gallons of paint were used to renovate the structure. The Blossom Heath entrance sign was removed from the driveway at this time. After 1951, city offices were at Blossom Heath until April 1957.

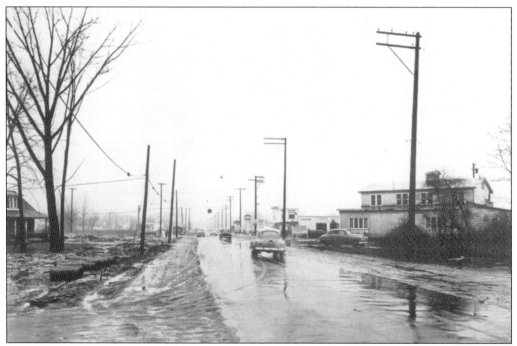

JEFFERSON AVENUE LOOKING NORTH AT NINE MILE ROAD IN 1952. The St. Clair Shores Engineering Department photographed Jefferson Avenue on January 26, 1952, before new paving and streetlights were installed. Light fixtures were suspended over the middle of the road at that time.

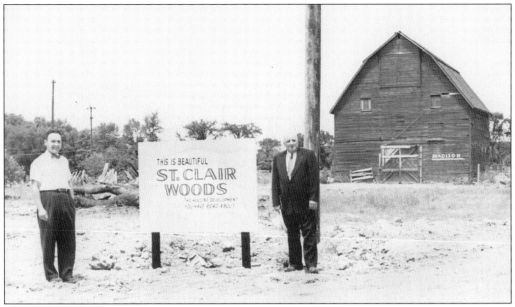

ST. CLAIR WOODS SUBDIVISION, 1954. The old and the new co-exist in this photo of the St. Clair Woods subdivision developers. Taken July 17, 1954, the barn is about to make way for new houses in the 1950s building boom.

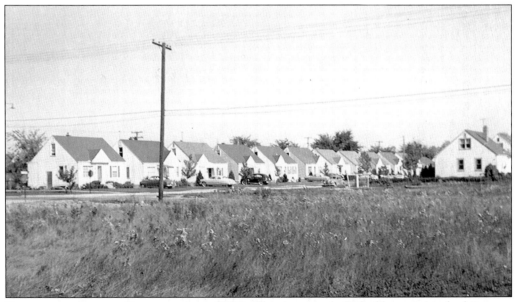

BLACKBURN STREET DEVELOPMENT, 1956. This is a view of Blackburn street looking east from Greater Mack, September 28, 1956. Bungalows line the street. Sewer pipes are being installed. This image was photographed from the Walter family residence at 22206 Blackburn.

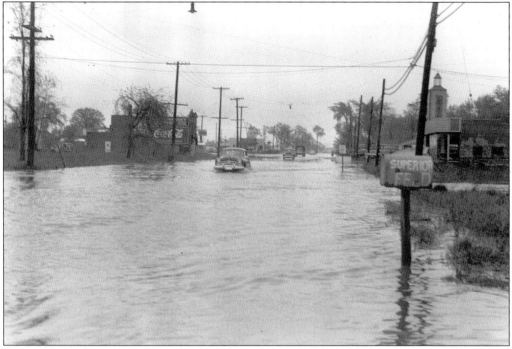

FLOODING ON HARPER AVENUE, 1948. The pressing need for adequate storm sewers is evident in this photo of Harper Avenue looking north from Nine Mile Road taken on May 12, 1948.

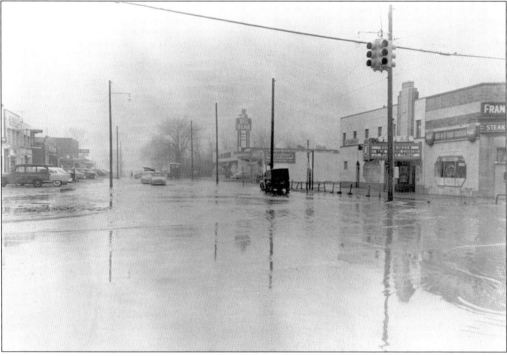

FLOODING AT GREATER MACK AND NINE MILE ROAD, 1953. Greater Mack looking south from Nine Mile Road is awash near the Big Bear Market and Shores Theater in 1953.

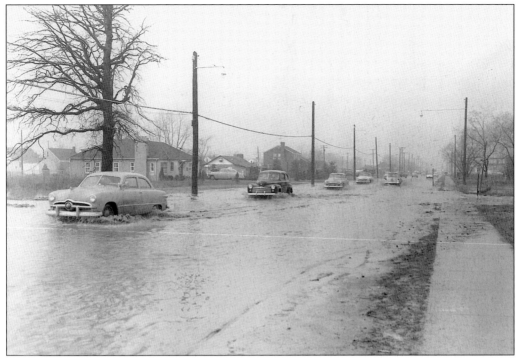

FLOODING AT NINE MILE AND HARPER, 1954. A single line of cars in this 1954 photograph forded Nine Mile Road and Harper Avenue.

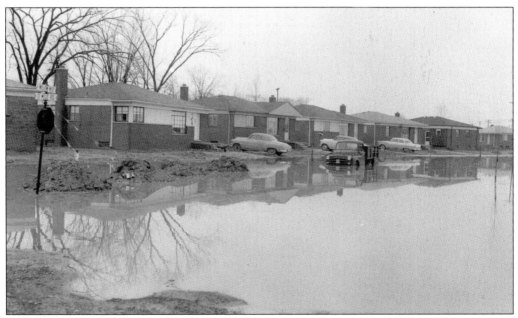

FLOODING ON WILLOW WISP, 1956. The residential streets such as Willow Wisp Street at Thirteen Mile Road resembled lakes in 1956.

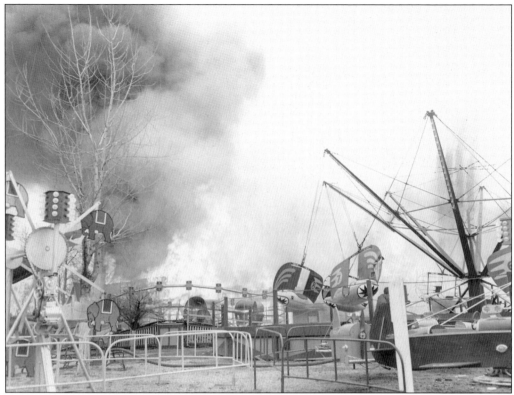

JEFFERSON BEACH FIRE, 1955. Viewed from Kiddie Land, smoke billowed up from the fire at Jefferson Beach Amusement Park, which started in the fun house and concession building April 15, 1955.

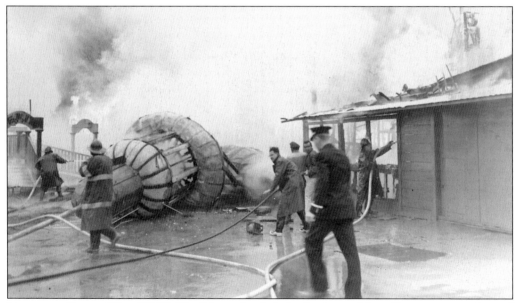

JEFFERSON BEACH FIRE, 1955. Firefighters battled the fun house blaze. Damage was estimated at $100,000. The fun house was totally destroyed.

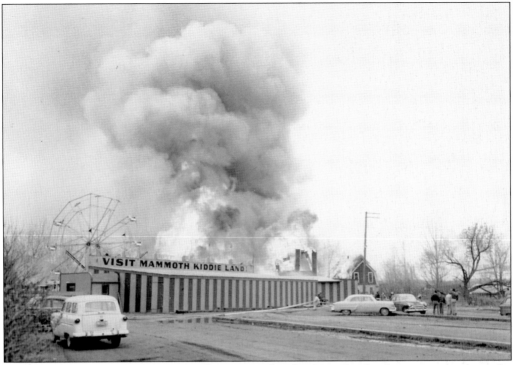

JEFFERSON BEACH FIRE, 1955. Smoke rises in the sky from the fun house as seen from the parking lot.

JEFFERSON BEACH AMUSEMENT PARK DEMOLITION, 1959. Jefferson Beach Amusement Park closed in 1959. The rides were sold and the remaining park structures were razed, except for the ballroom, which was used for boat storage. Expansion into a full-time marina swiftly followed.

GILBERT'S HARDWARE. Small businesses thrived in the new city of St. Clair Shores. Gilbert's Hardware on Harper Avenue is shown here in December, 1950 just before the city's official birthday.

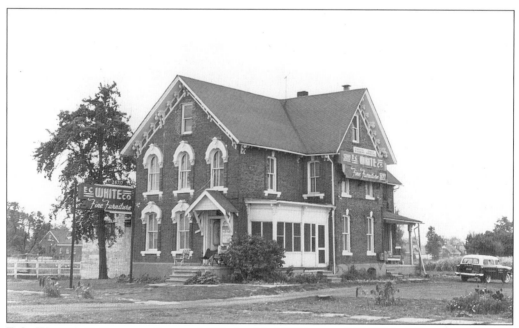

E.C. WHITE'S FURNITURE STORE, 1955. In this 1955 image, E.C. White's Furniture Store at Little Mack and Ardmore Park is operating in the farmhouse built by Frederick Schroeder in 1870. During the 1930s it was a roadhouse. In 1937 the cinderblock ballroom was added. In 1942 it was Renny's Lodge. Ruth and Danny DiSanti opened the furniture store in 1953. Ruth's father, E.C. White, founded the Gardner-White Furniture Co. in 1908.

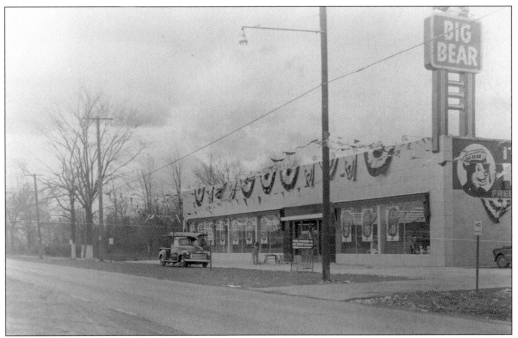

BIG BEAR MARKET, C. 1950S. The first supermarket in St. Clair Shores was the Big Bear Market on Greater Mack near Nine Mile Road. One-stop marketing gave the smaller meat markets and "mom and pop" stores a lot of competition.

RADKE HARDWARE, C. 1960S. Radke's on Nine Mile Road near Greater Mack was one of the city's most popular hardware stores. Radke's also did a booming business in ice hockey supplies and equiptment and was the place to get your skates sharpened.

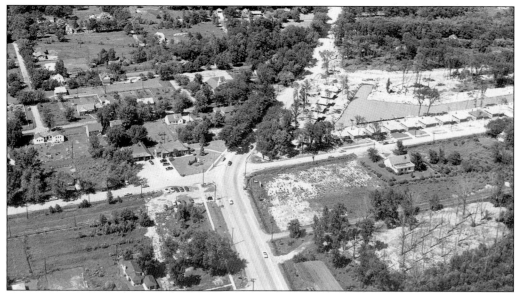

AERIAL VIEW OF ELEVEN MILE ROAD AND JEFFERSON AVENUE IN 1955. This aerial view shows the site of the new civic center to be built on the southeast corner of Eleven Mile Road and Jefferson Avenue. The old Police/Fire/Municipal building is on the northeast corner. The white frame building on Eleven Mile Road east of Jefferson Avenue housed the library

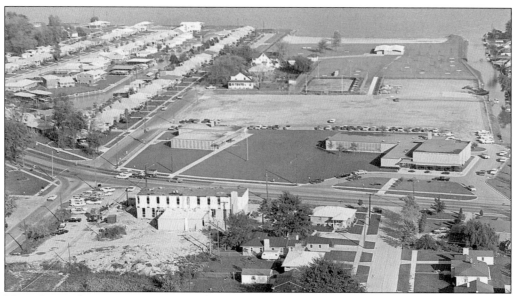

NEW CIVIC CENTER, C. 1961. This aerial view of Eleven Mile Road and Jefferson Avenue shows the new city hall (opened in April 1957), the new library (opened in 1958), and the new police station under construction.

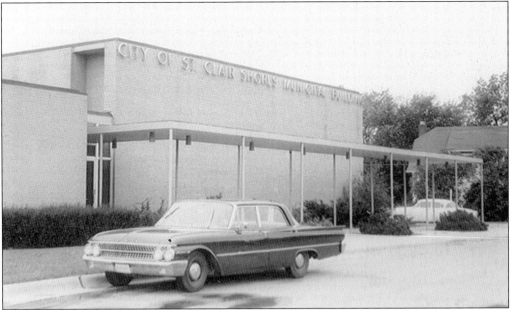

FRONT OF NEW CITY HALL, C. 1962. Here is the new city hall built in 1956/1957. Municipal offices moved from Blossom Heath to this new building in April 1957.

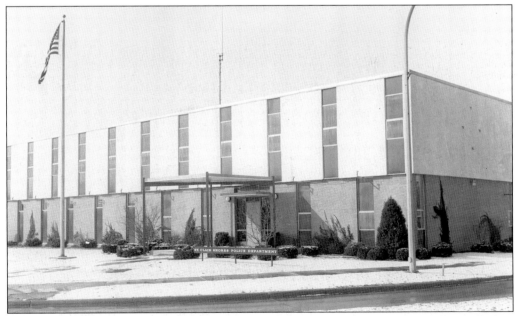

ST. CLAIR SHORES POLICE HEADQUARTERS, 1970. Opened May 9, 1962, with a staff of 62 officers, the police headquarters is still in use in 2001. The building provided three times the space of the old municipal office. By 1970 the department had 96 officers, 30 vehicles, 30 crossing guards, and 8 clerks.

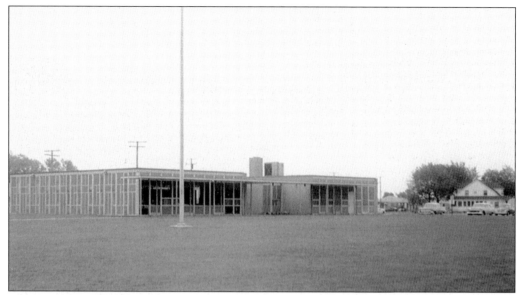

ST. CLAIR SHORES PUBLIC LIBRARY, 1958. With a city population of 40,000 in 1956 and 18,000 books in the old library, it was time for a new building. In the fall of 1956, voters approved a $100,000 bond to construct a new library just west of the old one. The 7,200-square foot building had shelves for 40,000 volumes and seating for 75. Mrs. Virginia MacHarg was appointed director in October 1959.

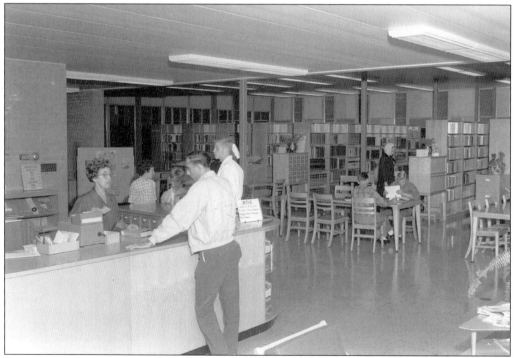

THE LIBRARY CIRCULATION DESK, C. 1960S. Library systems are constantly evolving. Checking out books by hand and looking up books in card catalogs was the style in the 1960s, along with the hard wood chairs to sit on.

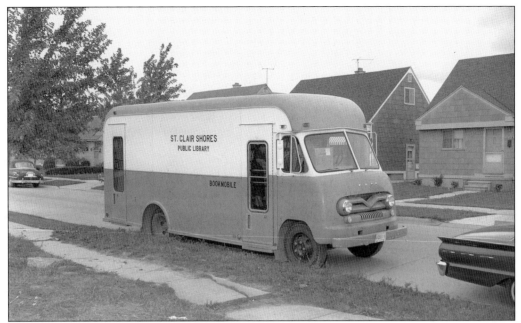

THE BOOKMOBILE, C. 1960S. In January 1955, the Bookmobile service began, visiting designated stops around the city. Browsing the shelves for children's books or a novel was a fun memory for many residents. Bookmobile service ended on November 3, 1982.

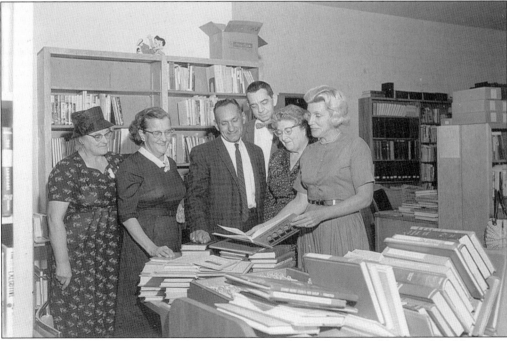

ST. CLAIR SHORES LIBRARY BOARD, 1962. Library Director Virginia MacHarg was photographed with the Library Board in 1962. They are, from left to right: Mrs. A.J. Bohnhoff, Mrs. MacHarg, Richard Turner, Robert Webber, Mrs. O. Stryker, and Mrs. E.T. Hauslein.

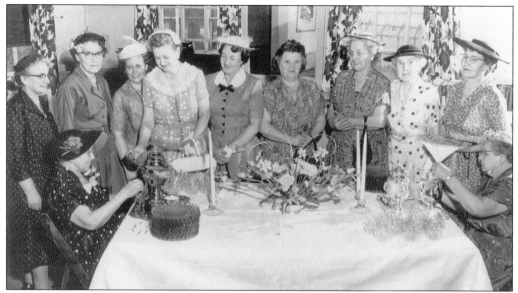

WOMEN'S STUDY CLUB TEA, C. 1955. The Women's Study Club was instrumental in forming the public library which opened in September 1935. Seated pouring tea in 1955 are, from left to right: (seated) Mrs. William Tuchell, and Mrs. Bert Karsboom (President); (standing) Mrs. A.L. Edwards, Mrs. O.A. Miller, Mrs. Ed Samer, Mrs. Joseph Backer, Mrs. Joseph Weiladt, Mrs. A.J. Thibodeau, Mrs. J. Fred Smith, and Mrs. John MacDonald.

WOMEN'S STUDY CLUB GARDEN, 1998. A secluded garden by the less-traveled Jefferson Avenue entrance to the St. Clair Shores Public Library was dedicated to the Women's Study Club on October 17, 1998. Classic irises (the club's emblem) and flowers from the 1930s were planted as the theme of the garden.

WOMEN'S CIVIC LEAGUE OF ST. CLAIR SHORES CARD PARTY, C. 1955. Card parties and teas were popular fundraisers for the women's clubs. This card party was held at the St. Clair Shores Civic Center ballroom in 1955. Founded in 1939, the Women's Civic League is one of the city's oldest continuous operating clubs. The Civic League has improved community service, helped develop Veteran's Memorial Park, and hosts the annual Town Hall meetings for voting local candidates and local issues.

VIOLINIST MR. RUBINOFF AND WOMEN'S CIVIC LEAGUE MEMBER MRS. CHARLOTTE ZUROW. The Women's Civic League also helped to establish the local symphony. The first concert of the St. Clair Shores Symphony was held October 5, 1962, with Italo Babini, cellist of the Detroit Symphony Orchestra, as director. The symphony had 40 members. The orginal friends group, the Symphony Accelerators for St. Clair Shores, held dances, card parties, and bake sales to support the symphony.

WOMEN'S CIVIC LEAGUE MEETING, 1959. Mayor Tom Welsh on left and council candidates address issues at the Women's Civic League meeting of February 28, 1959.

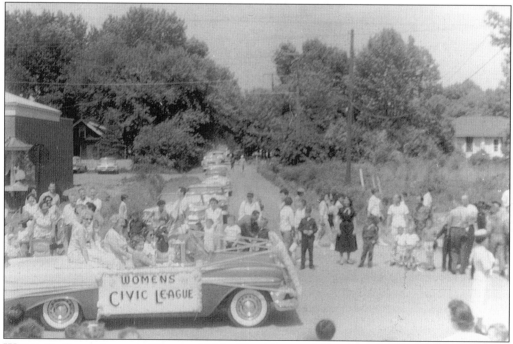

WOMEN'S CIVIC LEAGUE FLOAT, 1959. The Memorial Day Parade of 1959 included the Women's Civic League officers riding in an automobile. The league is very active in community events and elections at the present time.

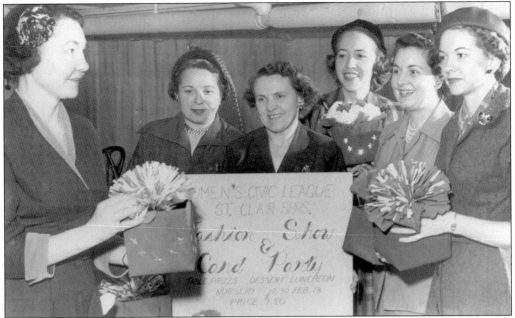

WOMEN'S CIVIC LEAGUE PARTY, 1954. The fashion show and card party fundraiser was earmarked for Memorial Park improvements. Mrs. Leslie Van Womer was chairperson of the event.

WOMEN'S CIVIC LEAGUE AND MAYOR WELSH, 1954. Mayor Tom Welsh holds the new model of Memorial Park with Women's Civic League Officers in 1954. The League was instrumental in the 1940 site selection and design process for the park as well as fundraising.

DEVELOPING MEMORIAL PARK, 1953. A dump truck offloads dirt for the development of Memorial Park. Tons of rubbish and old building materials had to be cleaned up. Fill dirt was brought in and leveled to build the park.

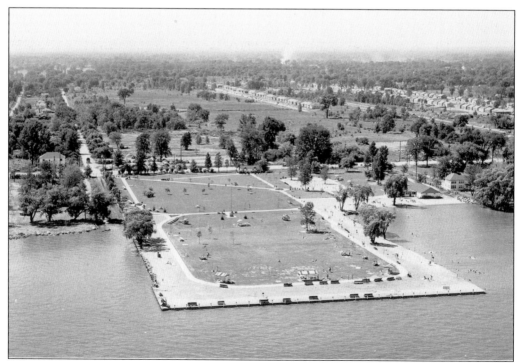

AERIAL VIEW OF MEMORIAL PARK, 1955. This aerial view taken from Lake St. Clair in June 1955 shows the grass and shoreline development of the park. The new trees will provide shade in the years to come.

CONCERT AT MEMORIAL PARK. Wednesday night concerts on the shore of Lake St. Clair are a popular family attraction in the summer today.

VETERANS MEMORIAL PARK. In 2000 Memorial Park was renamed in honor of the veterans from St. Clair Shores. Within the park is a stone monument to the veterans, which was moved from the old municipal building grounds.

BLUE STAR MOTHERS AT VETERANS MEMORIAL, 1947. Blue Star Mothers who had sons in the service during World War II surround the memorial at the old municipal building. If a son was lost in service she became a gold star mother.

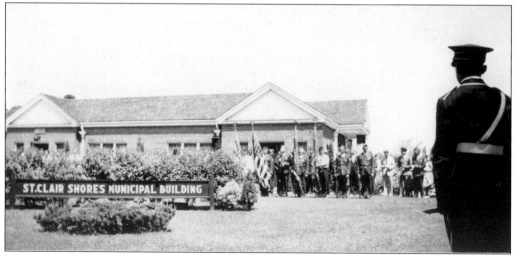

MEMORIAL DAY CEREMONY, 1960–1962. Veterans gather for a flag ceremony on the old municipal building grounds. VFW Bruce Post #1146 was chartered August 21, 1934.

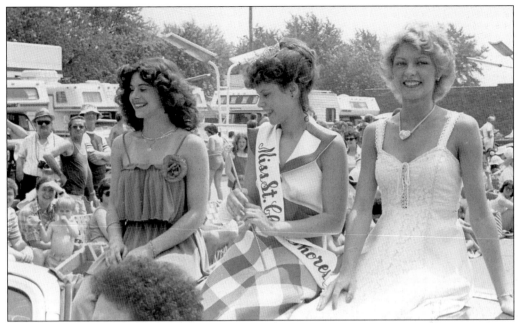

MISS ST. CLAIR SHORES IN MEMORIAL DAY PARADE, 1978. Miss St. Clair Shores Melodie Lee Olson and her court ride in the parade. The first St. Clair Shores Memorial Day Parade was held following World War II and is today one of Michigan's largest.

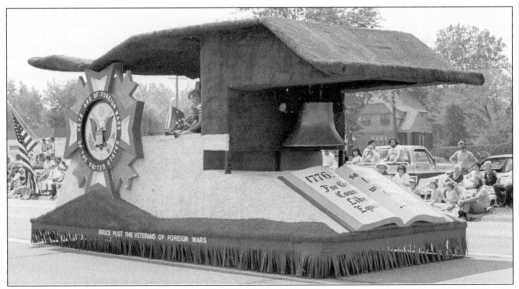

VFW FLOAT, 1978. The Veterans of Foreign Wars (VFW) constructed this float in 1978 for the Memorial Day Parade. It featured a replica of the liberty bell, a book, and the VFW emblem.

MOVING THE SELINSKY-GREEN FARMHOUSE, 1975. Avoiding traffic lights and power lines was a major difficulty in moving the Selinsky-Green house from Eleven Mile Road at Grant to its new home on Eleven Mile Road behind the Library.

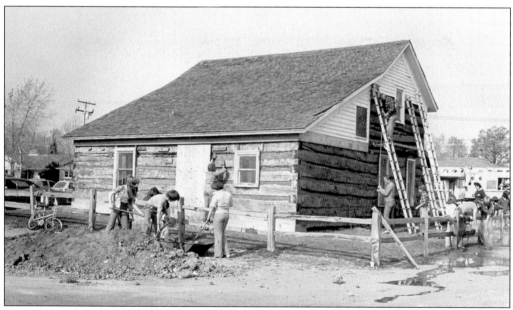

RENOVATING THE SELINSKY-GREEN FARMHOUSE. The split log construction of the Selinsky-Green saltbox style house is evident in this restoration photograph. Wood clapboard covers the rough logs. Restoration took six years to complete.

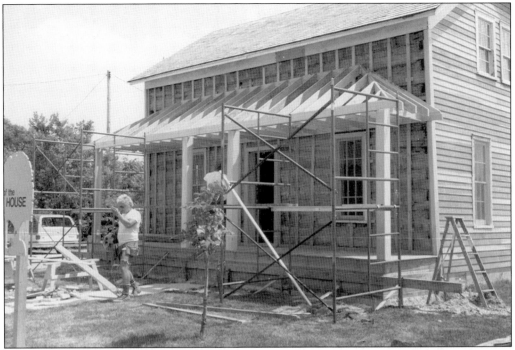

SELINSKY-GREEN FARMHOUSE RECONSTRUCTION, 1980. Totally rebuilding the porch on the farmhouse was necessary. The overhang, floor boards, and railings were restored to the original condition of the house.

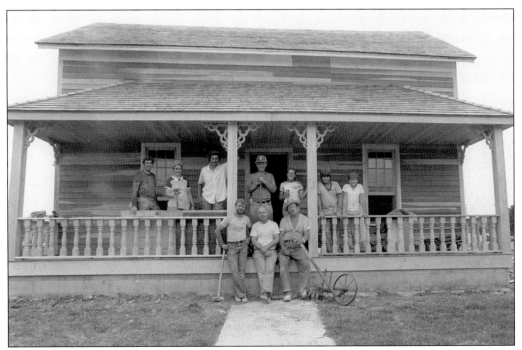

RESTORATION CREW, AUGUST 9, 1980. Volunteer workers take a break on the porch of the Selinsky-Green Farmhouse in 1980. The farmhouse is about ready for a coat of white paint.

St. Clair Shores City Band, 1952. Mr. McKenna directs the City Band practice. For years, during the 1950s, the city band was an important part of the city's cultural activities.

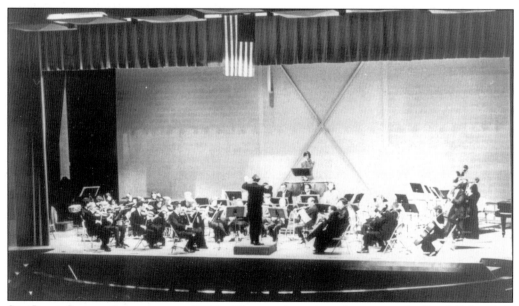

St. Clair Shores Symphony, c. 1970s. The symphony is performing in the South Lake High School auditorium in this photo. In the 1960s the group rehearsed in the old Lakeview High School. A concert was performed at each high school in October, December, winter, and spring.

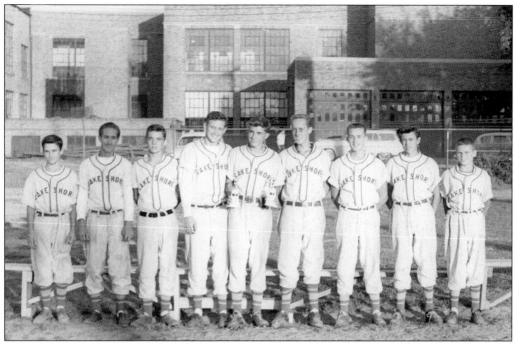

LAKE SHORE HIGH SCHOOL BASEBALL TEAM. Baseball has long been a popular sport in all of the city's three public high schools.

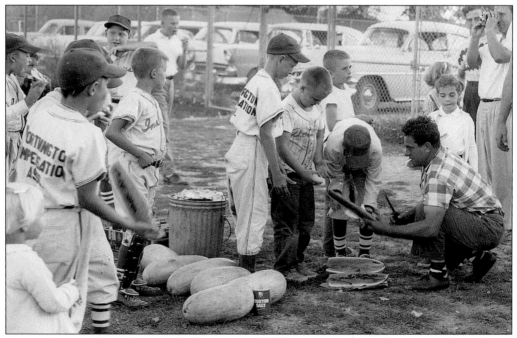

LITTLE LEAGUE BASEBALL. Little league baseball has also been popular in St. Clair Shores. The St. Clair Shores Baseball Association was organized in 1973 to work with the Recreation Department to purchase uniforms and to set up league rules and policies. Here players are enjoying watermelon after a game.

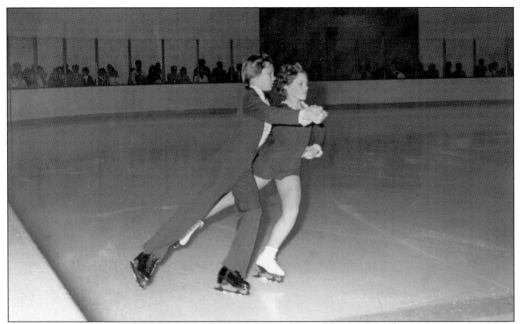

SHORES ICE SKATING CLUB. A pair of ice dancers perform at the civic arena in November 1978. The figure skating club has produced world class skaters under the direction of top skating coaches. The ice show is a popular event each year.

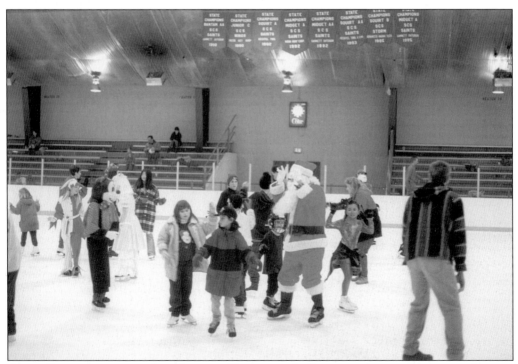

OPEN SKATING AT THE ICE ARENA. Skating with Santa at the ice arena is a favorite holiday activity.

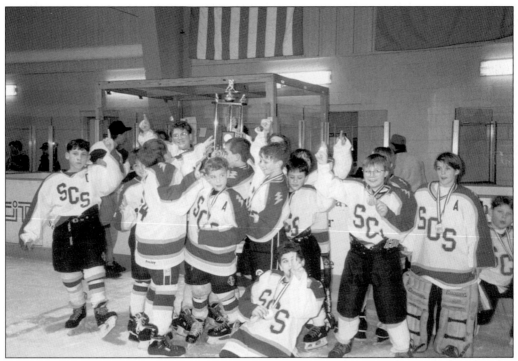

ST. CLAIR SHORES HOCKEY LEAGUE CHAMPIONS, 1996. Happy players gather for this group photo after clinching the league title in 1996. With two ice rinks, practice time is still competitive for figure skaters, hockey players, and open skating.

EXTERIOR OF ST. CLAIR SHORES CIVIC ARENA. The arena also shares space with the Senior Center. Many activities and trips are available for residents over age 50.

ST. CLAIR SHORES GOLF COURSE CONSTRUCTION, 1973. The renovation of the old
Lakepointe Country Club golf course, which had taken over the Masonic Club course, began
in 1973. Top soil was scraped from the tees and greens, then mixed with sand. The fill dirt
underneath was used to regrade the course. The landmark golf course water tower is in the
background of this photo.

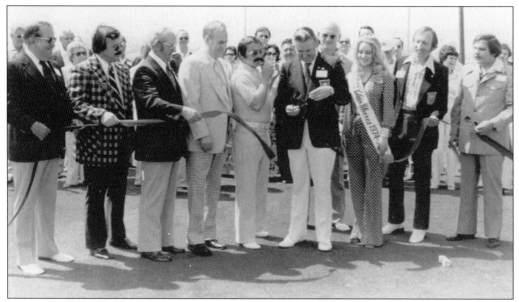

GOLF COURSE DEDICATION, MAY 18, 1975. Mayor McPharlen, the City Council and Miss
St. Clair Shores 1974–75 are cutting the ribbon at the #10 tee. Ground was also broken for the
new clubhouse that day.

GOLF COURSE WATER TOWER, 2000. Wearing a fresh coat of paint, the landmark water tower may be seen for miles around the golf course on Masonic Boulevard.

GOLF COURSE FOUNTAIN, 2000. The fountain is one of many landscaping details, along with trees and manicured greens that golfers enjoy on the course.

WILLIAM C. MILLER BEACON AND SHORE CLUB APARTMENTS. The William C. Miller Beacon, named for the marina pioneer, was hoisted by helicopter to the top of the Shore Club Apartments on July 9, 1971. Light from the 60 pound beacon can be seen 25.6 miles across Lake St. Clair.

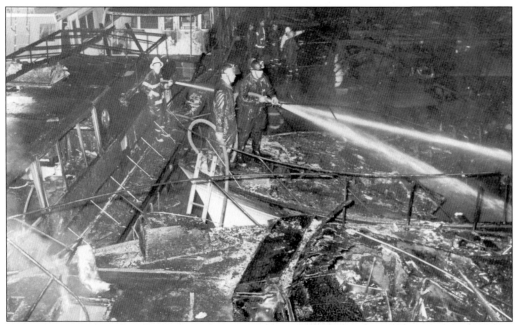

EMERALD CITY MARINA FIRE, MARCH 30, 1974. Marinas have often been the scenes of fires on the Nautical Mile in part because of diesel fuel in the boats, wooden buildings and docks, and electrical wiring. One such blaze was at Emerald City Marina in March of 1974.

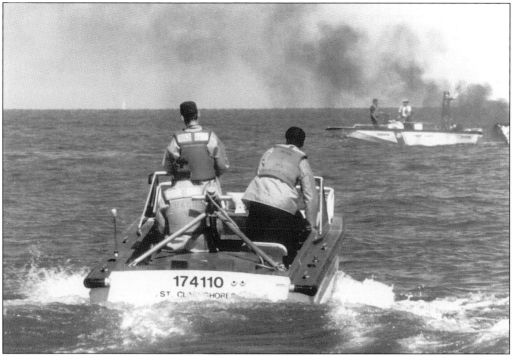

FIRE BOAT TRAINING. Besides fighting fires on land, the St. Clair Shores Fire Department is prepared to assist in fire rescue on Lake St. Clair involving boats or marinas. This is a training exercise with the U.S. Coast Guard.

MARINA STORAGE. Year-round boat service is available at the Nautical Mile Marinas. Here a sailboat approaches the hoist which lifts boats out for storage on trailors or on racks in buildings.

SANDBAGGING, FEBRUARY, 1973. The memorable high water levels of Lake St. Clair in the winter of 1973 forced residents to sandbag the shoreline and around houses. The U.S. Army Corps of Engineers constructed dykes and closed canals, pumping out water to prevent storm damage. The Lakeview High School students pitched in on Milner Canal. In 2001 the lake is at one of its lowest levels in history.

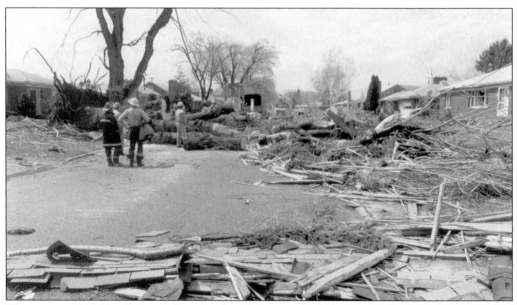

TORNADO OF 1983. Occasionally tornadoes have touched down near the shoreline instead of continuing over the lake. The tornado of 1983 damaged houses and property on Lakecrest Street and the canal along Benjamin Street. These photos were taken by the Nothdurft family.

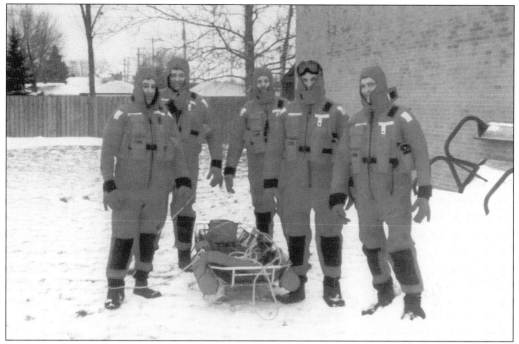

St. Clair Shores Fire Department Ice Rescue Team, 1997. The Fire Department frequently assists in the ice rescue of fishermen in the winter. They are, from left to right: Jim Haddad, Mark Murry, Walt Jenuwine, Chris Krotche, and Dan Geffert.

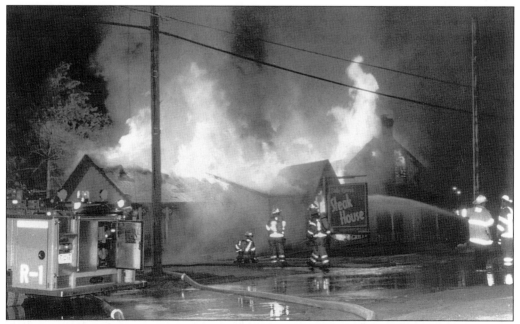

Fire at Bobby Moore's Steak House, 1997. The fire at Bobby Moore's Steak House, located at the corner of Jefferson Avenue and Ten Mile Road, destroyed the landmark farmhouse owned by the Labadie family. The site is scheduled to be the new home of a Middle Eastern restaurant.

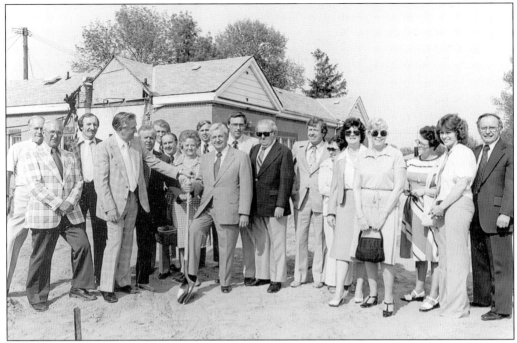

40TH DISTRICT COURT GROUNDBREAKING CEREMONY. On May 25, 1978, city officials gathered at the groundbreaking for the new 40th District Court Building. They are, from left to right, as follows: City Manager Donald J. Harm, Councilman Casper J. Frederick, Gordon A. Dressel, Mayor Frank J. McPharlin, Contractor Robert J. Koepsell, Engineering Department Aide Benjamin Heanjious, Assistant to the City Manager Robert S. Helmer, Mrs. John H. Yoe Sr., City Librarian Arthur M. Woodford, John H. Yoe Sr., Councilman Joseph R. Krutell, Marcel A. Werbrouck, Judge Craigen J. Oster, Court Employee Elanor Gunn, Court Administrator Dorothy Quinlan, Court Employees Mary Pope, Jeanne Stover, Barbara Hernderson, and City Assesor Fred A. DeBusscher.

ENTRANCE TO 40TH DISTRICT COURT, 2000. Dedicated to John H. Yoe Sr., long time city attorney, the brick courthouse encompasses part of the walls of the old municipal building originally built at the northwest corner of Jefferson and Eleven Mile Road in 1934.

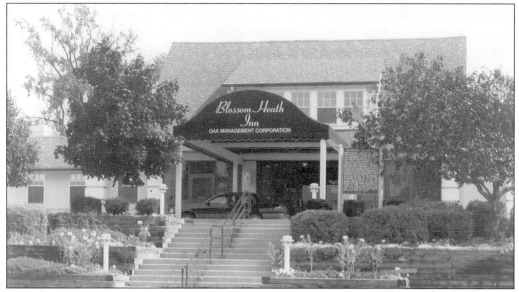

ENTRANCE TO BLOSSOM HEATH INN, 2000. The attractive covered entrance to Blossom Heath also has a driveway up to the front doors. Operated by Oak Management, Blossom Heath caters weddings, showers, and meetings in the historic ballroom.

ST. CLAIR SHORES MAYORS. On May 10, 1996, City Clerk Jack L. Fields invited the mayor and eight living former mayors to gather together to recall their days in public office. Following that meeting this group picture was taken. The mayors, both past and present, from left to right, are as follows: John A. Roberts, 1969–1971, 1981–1983; Frank J. McPharlin, 1971–1981; William J. Callahan, 1995; Curtis L. Dumas Jr., 1995–present; Ted B. Wahby, 1983–1994; Roy M. Geer, 1965–1969; Eugene J. Ellison, 1961–1965; Tomas S. Welsh, 1952–1960; and Marcel A. Werbrouck, 1981.

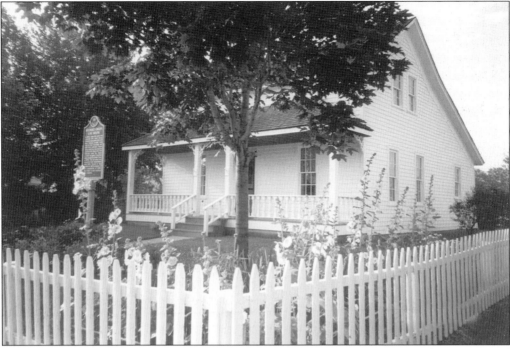

SELINSKY-GREEN FARMHOUSE MUSEUM, 2000. A country garden, white picket fence, and historical marker accent the grounds of the Selinsky-Green Farmhouse. The house, now the city's historical museum, is open to the public and used for demonstrations, showers, birthday parties, weddings, and quilting meetings.

THE ST. CLAIR SHORES PUBLIC LIBRARY, 2000. The Jefferson entrance of the St. Clair Shores Public Library is behind the nautical wood library sign. The Women's Study Club Garden is on the right before the entrance.

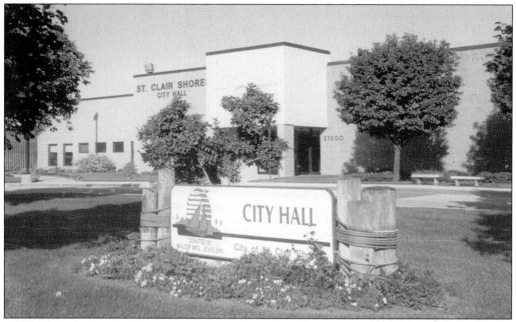

ENTRANCE TO CITY HALL, 2000. The newly renovated city hall has a curved driveway in front of the Jefferson Avenue entrance.

ST. CLAIR SHORES CITY HARBOR, 2000. Located behind the library and city hall complex, the City Harbor provides a seasonal marina, pool, and waterslide to residents.

WAHBY PARK, 2000. Named for former Mayor Ted Wahby, the front grounds of Blossom Heath at Jefferson Avenue have been transformed into a park with bridges and pillars surrounding a flowing stream. This has become a popular spot for wedding photographs.

NAUTICAL MILE SIGN, 2000. The nautical mile between Nine Mile and Ten Mile roads is the home of many marinas, fine restaurants, and boat suppliers. This welcome sign and message board help residents to keep up-to-date on shoreline events.

St. Clair Shores Millennium Clock, 2000. The sailboat clock, dedicated January 1, 2000, is a new landmark in the city as St. Clair Shores enters the new millennium. It is on the lawn in front of the library and city hall on Jefferson Avenue at Eleven Mile Road.

BOOK DESIGN TEAM PHOTO. From left to right: Cheryl A. Goodall (Photo Technician/Layout Assistant), Cynthia Bieniek (Archivist), August Blumline (Chairperson of the St. Clair Shores Historical Commission), Arthur M. Woodford (City Librarian).

Acknowledgments

This pictorial history prepared to help celebrate our city's 50th anniversary is like any book of this type—it is the work of many people. We would first like to thank the members of the St. Clair Shores Historical Commission for their support and encouragement: August Blumline, chairperson; Richard Jacob, vice-chairperson; Gerald L. Sielagoski, secretary; and members John Cilluffo, Fred A Hessler, L. Michael Lozon, Jane Mallwitz, Lillia McMacken, and Gerald Perry.

The actual preparation of this book was also the work of several people. City Librarian Arthur M. Woodford selected the photographs, Librarian/Archivist Cynthia Bieniek wrote the captions, Library Computer Technician Cheryl A. Goodall scanned the photos and prepared the text for electronic transmission, and Historical Commission Chairperson Gus Blumline assisted with the editing.

The images used here were all selected from the more than 3,000 photographs contained in the archives of the St. Clair Shores Historical Commission which are housed at the St. Clair Shores Public Library. These photographs originally came from a variety of sources, but we would like to take this opportunity to recognize the contributions of Herman Allen, Gary Gardecki, Harry Krause, Jack Schramm, and especially August Blumline.